IMAGES
of America

MILWAUKEE'S BRADY STREET
NEIGHBORHOOD

On the cover: East side revelers enjoy the Tumble Inn, a popular Italian-owned tavern on Lyon and Van Buren Streets, in this 1937 photograph. As Italians worked their way out of the squalor and crowding of the Third Ward south of downtown, many moved to the east side, especially the area south and west of Brady Street. (Courtesy of the Italian Community Center–Milwaukee.)

IMAGES
of America

MILWAUKEE'S BRADY STREET NEIGHBORHOOD

Frank D. Alioto

ARCADIA
PUBLISHING

Published by Arcadia Publishing
Charleston, South Carolina

Printed in the United States of America

Library of Congress Catalog Card Number: 2007936433

For all general information contact Arcadia Publishing at:
Telephone 843-853-2070
Fax 843-853-0044
E-mail sales@arcadiapublishing.com
For customer service and orders:
Toll-Free 1-888-313-2665

Visit us on the Internet at www.arcadiapublishing.com

To Rachelle, my wife, my love, and my tech support, and our children, Samuel and Alyssa. If not for your support and patience through this grueling but rewarding process, I would still be on page 1.

CONTENTS

ACKNOWLEDGMENTS

If I thanked everyone who helped me through this process it might just fill the entire book, so I must generalize. Thank you to everyone who provided pictures and/or information for captions. Also thank you to those of you at the Milwaukee Public Library and the Milwaukee County Historical Society and other local institutions for putting up with my tenacity this past year. Thanks especially to my wife, Rachelle, for encouraging me to combine two passions of mine—my love of neighborhood history and my love of writing. Finally, thank you to all who live, work, and play in the Brady Street neighborhood for your encouragement and enthusiasm in our collective heritage.

INTRODUCTION

Brady Street. To Milwaukeeans, the name alone evokes fond memories, colorful imagery, and a diversity of opinions. To some, it is a Polish immigrant village centered on St. Hedwig's Church. Many revere Brady Street as Milwaukee's "Little Italy," where their favorite sausage, rolls, and cannoli are worth a drive across town. In perhaps its most colorful era, Brady Street became the Haight-Ashbury of the Midwest, a stretch where beatniks, hippies, artists, and assorted freaky people congregated.

Brady Street is crowded, loud, and gritty—like a patch of New York City plopped in a more serene midwestern burg. Age-old ethnic stores and workers' cottages have been joined by boutiques, ritzy condominiums, and lively cafés, raising concerns of gentrification. It is a place that has repelled many suburbanites yet lured their children in droves. Now these empty-nested parents are following closely behind.

Remarkably, Brady Street is all those things and more. Arguably the most densely populated and ethnically diverse area in the state of Wisconsin, the neighborhood and its rich history are too complex to define in a few words. So if a picture is worth a thousand words, within this book are several hundred photographs of the buildings that have defined the landscape—some long lost but most restored to former glory. More important are the images of people and events that have enlivened and popularized the neighborhood for some 150 years. From festivals and fires to mom-and-pop shops and holy spires, the images revealed within should bring nostalgic memories to folks who are familiar with Brady Street and inspire others to get acquainted with the neighborhood's many assets.

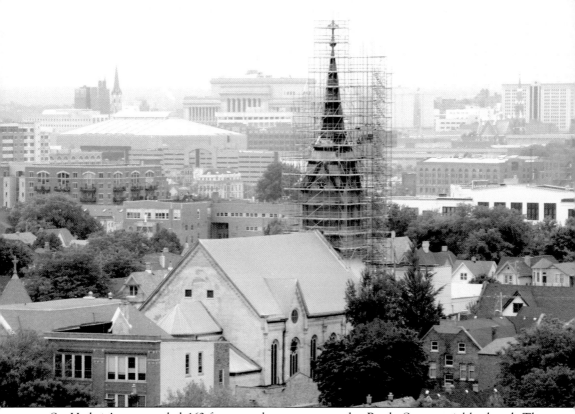

St. Hedwig's copper-clad 162-foot steeple towers over the Brady Street neighborhood. The face-lift this landmark is undergoing reflects an optimism and can-do spirit that neighbors today—regardless of their faith—share with those who built this icon. (Author's collection.)

One

AN OVERVIEW
AND SOME EARLY VIEWS

The Brady Street area began as a wooded highland hemmed on the north and west by the Milwaukee River and on the east by Lake Michigan. From the time of glaciers, little happened in the area save a few trails that Native Americans cut through. Milwaukee's original settlement was Juneautown, named for pioneer Solomon Juneau. Juneautown was established in 1820 nearly a mile to the south of today's Brady Street. The northern section of Juneautown was nicknamed "Yankee Hill," for the middle- to upper-middle-class residents who migrated there from the East Coast starting in the 1830s. Juneautown established a cemetery at what is now Humboldt Avenue and Brady Street, and many of the remains still lie beneath the buildings at the southwest corner.

By the 1860s, Yankee Hill steadily expanded northward toward Brady Street. The architecture south of Brady Street is an eclectic mix of large Victorian-era homes and modest cottages. Also found are quaint row houses of the type more often found on the East Coast (or even Europe) than in the Midwest, as well as an influx of early-20th-century apartment buildings. Brady Street itself became a commercial district of Yankee- and German-owned shops built in the 1880s.

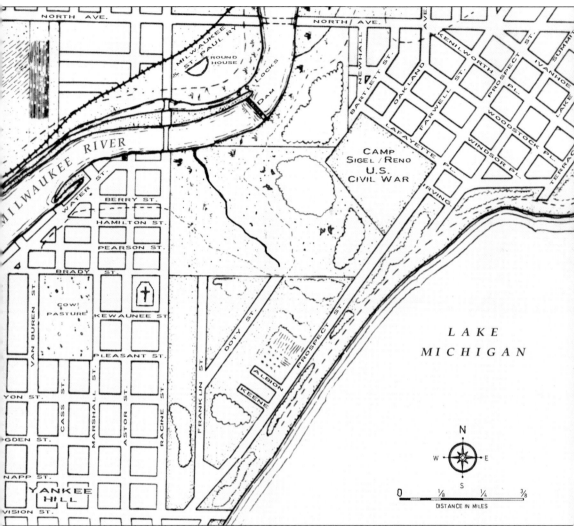

This map is not of a specific year but rather shows the Brady Street area's geography, early streets, and early land uses through the mid-1800s. The site of the first cemetery to serve the entire area was the southwest corner of what is now Brady Street and Humboldt Avenue. Human remains still exist on this site and have been discovered during street building and basement excavations through the years. The creek and swampy ravine that were filled to become the footprint of Pulaski Street are seen just north of Brady Street. A cow pasture and Civil War campsite are also depicted as well as the Yankee Hill neighborhood to the south. (Courtesy of the University of Wisconsin–Milwaukee Cartography and Geographic Information Science Center.)

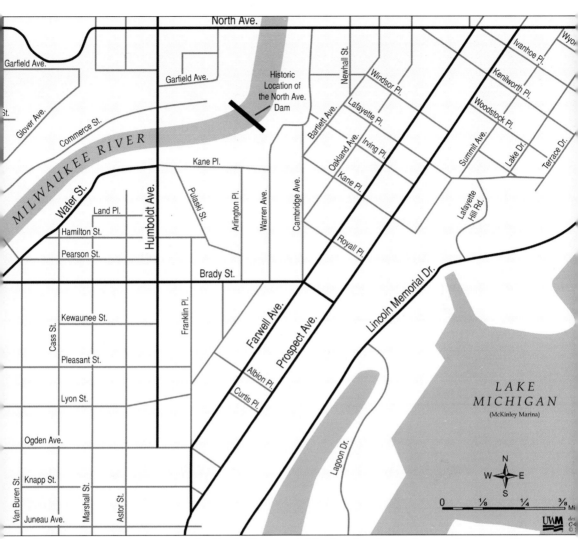

Here is an up-to-date map of the Brady Street neighborhood to be used as a reference guide. Notice the streets are laid out on two intersecting grids. One is horizontal and vertical, consistent with most of Milwaukee's layout. The other is tilted to follow the contour of Lake Michigan. The intersection points create triangular blocks. Quirky Pulaski Street, the one exception, meanders above an old creek path and was built upon by Polish immigrants before city officials could intervene. (Courtesy of the University of Wisconsin–Milwaukee Cartography and Geographic Information Science Center.)

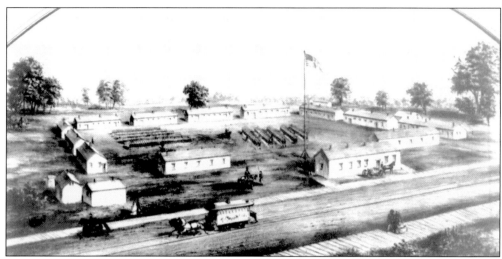

As the nation prepared for civil war, several camps were created to muster young troops before their train ride south to the battlefronts. Camp Sigel was built between what is now Oakland Avenue and the lake bluff north of Royall Place. Gen. Franz Sigel, its namesake, lost 900 men at Bull Run, and the name was soon changed to Camp Reno, to honor Gen. Jesse Reno after his heroic victory at Antietam. The land was donated by Milwaukee pioneer George Walker. Maybe not coincidently, Walker owned the street railway that shuttled thirsty troops to area beer gardens. The first professional baseball game in Milwaukee was later played on the site in 1869. The Milwaukee Cream City club beat the Cincinnati Redlegs. (Courtesy of the Milwaukee County Historical Society.)

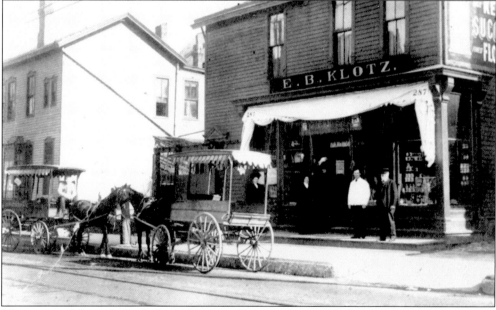

This is one of the only Brady Street horse-and-wagon photographs known to exist. In the early 1900s, Eugene Klotz owned a dry goods shop at 1027 East Brady Street just west of Racine Street, (now Humboldt Avenue). It is now Fazio's dry cleaning and Peter's barbershop. Brady Street emerged as a commercial district and was originally primarily German and Yankee owned. (Courtesy of the Glorioso family.)

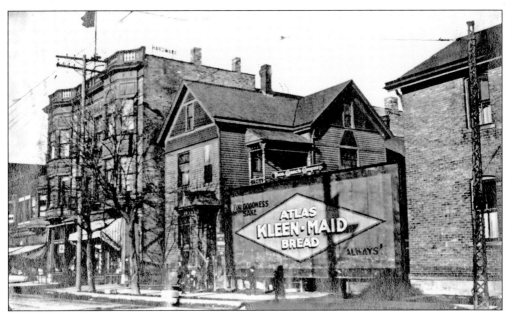

Giant billboards like this one hyping Atlas Bread dominated vacant lots along the street, presumably an improvement on open spaces. On the left is Charles Ross Hardware. The building has seen many uses but has gone full circle, and a century later, it is again a hardware store. The dwelling to its right now serves as a commercial building. (Courtesy of the Milwaukee County Historical Society.)

Under a canopy of trees in this 1880s view is a dry goods store at 816 East Brady Street. The building survives and recently opened as Anomaly, a gift shop. Most of Brady's west end was, and still is, residential. (Courtesy of the Milwaukee County Historical Society.)

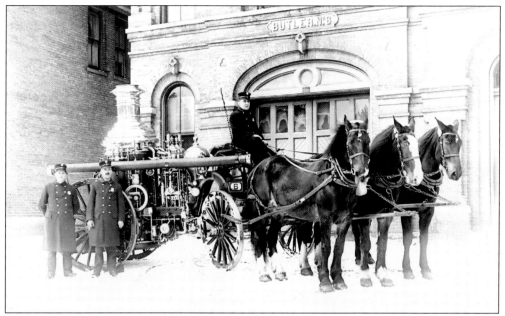

Engine Company 6 has continuously served the neighborhood from Franklin Place and Brady Street since 1875. Until motorized apparatus was introduced in the 1920s, firehouses were once glorified horse barns. Here three unidentified firefighters pose with their horses and shiny steam pumper—both needed extensive maintenance. The pumpers often blew as much smoke as the fires themselves. (Courtesy of the Milwaukee Fire Department Historical Society.)

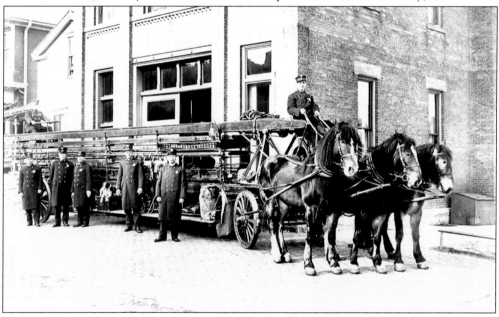

Ladder Company 5 served the area from a house at Bartlett Avenue and Irving Street from 1886 until 1914, when it moved north to Bartlett and Park Place. Ladder companies serve primarily as ventilation and rescue teams to support the engine companies and their hose lines. This building still exists as a storage facility for a private moving company and retains its original look. (Courtesy of the Milwaukee Fire Department Historical Society.)

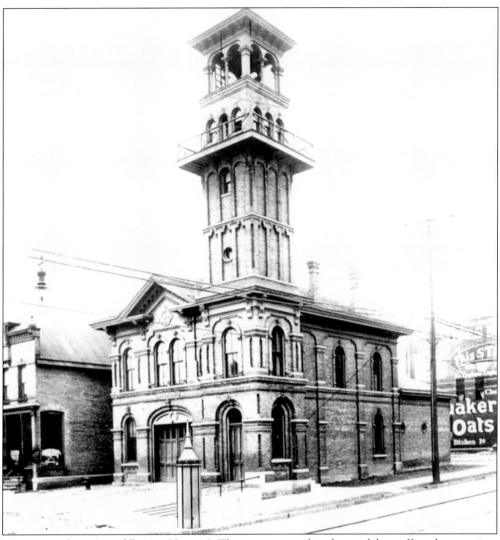

Here is another view of Engine House 6. The more streamlined remodeling effort that survives today makes one wonder, "What were they thinking?" The lookout tower, which rivaled St. Hedwig's steeple in height, was manned before telephones and alarm box systems were available. Mayor Ammi Butler, who served when the house was built, had his name embossed in the brick over the main door. Notice the police call box on the corner. (Courtesy of the Milwaukee Fire Department Historical Society.)

Brady Street at Farwell Avenue was a lively, bustling place even in the early 20th century. One can almost hear the rumble and clanging of the route 15 streetcar. The John Kunitzky building, built in 1880 for his saloon, dominates this end of the street. The top floor hid a speakeasy and gaming room during Prohibition. The second ever in the chain of Cousin's Subs is located here. (Courtesy of the Milwaukee County Historical Society.)

From the same intersection looking north up Farwell Avenue is another route 15 streetcar. The Victorian-era building on the left housed Smith and Weber Drugs from 1920 to 1950. This building was razed for the present Kinko's copy shop building in an urban renewal effort. (Courtesy of the Milwaukee County Historical Society.)

In the late 1800s, Milwaukee was among the leading cities in the nation in the number of immigrants pouring in. Many of their children suffered from various diseases with nowhere to turn. Eight prominent women were inspired to open a free hospital for children in this modest dwelling. The site is now a parking lot for Casablanca restaurant at 720 East Brady Street. The photograph below shows volunteer nurses tending to sick children. This effort steadily grew and is now Children's Hospital of Wisconsin. It boasts of over 2,000 employees and over 250 beds and is one of the most prominent children's hospitals in the nation. (Courtesy of Children's Hospital of Wisconsin.)

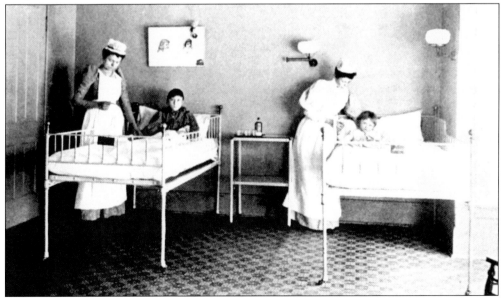

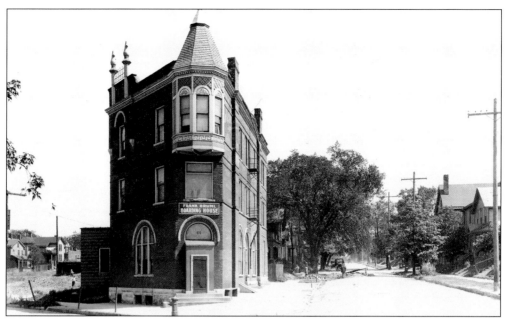

At the triangular intersection of Pearson and Water Streets stands this building that is now the popular Trocodaro restaurant. It was built by the Schlitz Brewery for saloon keeper Frank Druml in 1890 for just $8,000. It also served as a rooming house for new immigrants who worked in the tanneries that once literally surrounded the building—convenient, sure, but certainly less than ideal living conditions. What money that was not spent in the saloon was probably saved for a move up the hill. (Courtesy of the City of Milwaukee Public Works.)

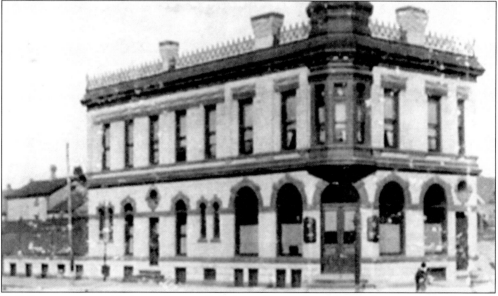

Buildings constructed by breweries to sell their product exclusively were known as "tied houses." This building, which still survives as Regano's Roman Coin, stands at the northeast corner of Astor and Brady Streets. The cupola did not stand the test of time. Built in 1890, it was designed by architect Otto Strack, who also designed the historic Pabst Theater. (Courtesy of Teri Regano.)

Across the river valley at the southwest corner of Humboldt and North Avenues stands another tied house. Built by the Miller Brewing Company and originally known as the Humboldt Garden, it had a stage for live music. It later became Zak's nightclub but now stands vacant. (Courtesy of the Wisconsin State Historical Society.)

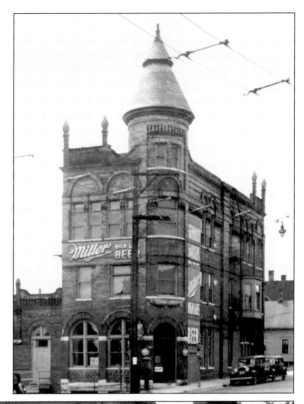

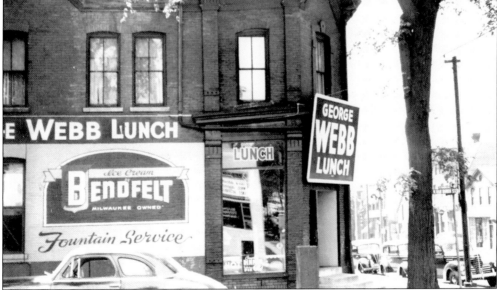

Here is another Milwaukee icon to blossom from the Brady Street neighborhood. In 1948, George and Evelyn Webb began a hamburger restaurant on the southwest corner of Van Buren Street and Ogden Avenue. The effort grew to over 40 restaurants throughout the area. George Webb long promised free burgers for a 12-game winning streak for the Brewers and Braves. It finally happened in 1987, and over 168,000 free burgers were given away. (Courtesy of George Webb Restaurants.)

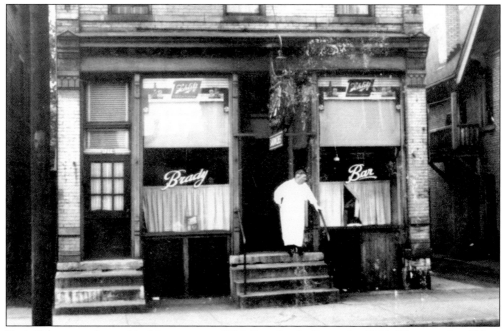

Paul Ehlert stands outside his tavern at 1216 East Brady Street in 1944. The popular Ehlert owned several bars through the years but never left Brady Street and was always active in issues that affected the neighborhood. The building now houses the Up and Under, a live blues bar. (Courtesy of Bob Ehlert.)

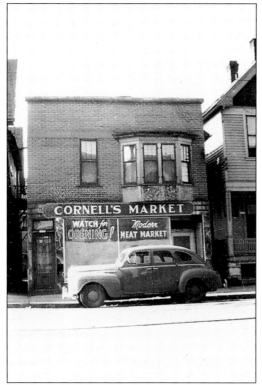

Cornell's Market readies for a grand opening. A 1941 Plymouth sits out front. Known as "Polish flats," many buildings were raised on jacks to add a new floor underneath, but this building has the distinction of being lowered. Once five steps up, it was slowly lowered by descending jacks to bring it to ground level. Perhaps the owner was afraid of heights! The building, at 1225 East Brady Street, is now the home of Miss Groove, a fancy boutique—a lower building with a higher end product line. (Courtesy of Don Jazdzewski.)

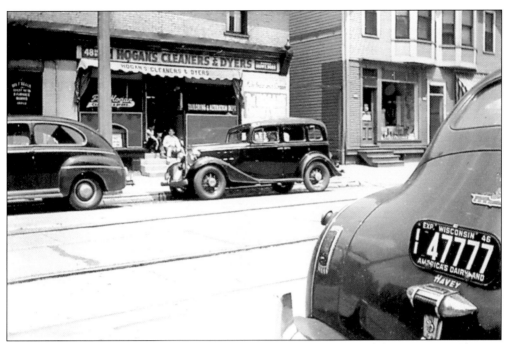

Across the street from Cornell's and framed by more vintage automobiles is Hogan's Cleaners and Dyers. It is now Brady Street Futons. (Courtesy of Don Jazdzewski.)

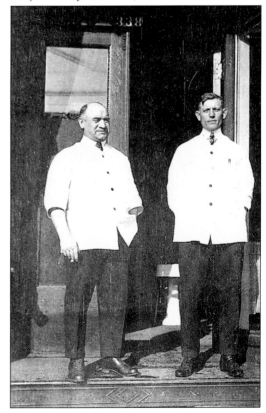

A duo of Brady Street barbers stands at the ready in front of their shop at 338 Brady Street about 1918. At left is Frank "Peggie" Kosminski, nicknamed due to a wooden leg. At right is John Masel. The building is now Brady True Value at 1234 East Brady Street. Incidentally, the city renumbered all addresses and renamed many streets in 1930. As a city that came out of a merge of three villages, the numbering system was initially chaotic, and streets changed names abruptly. (Courtesy of Don Jazdzewski.)

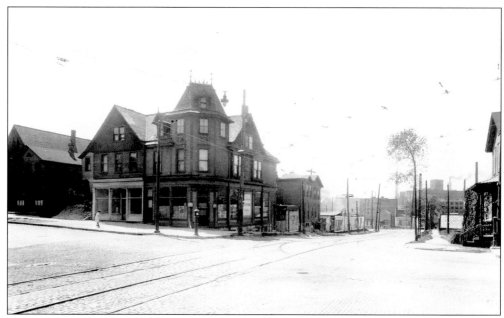

Early photographs of Brady Street are rare. Most people did not have cameras and those who did focused (so to speak) on family portraits. The following four images are city survey images done during the rebuilding and widening of the Holton Street Viaduct in 1927. Above, this ornate Victorian-era commercial building at the southwest corner of Brady Street and Van Buren Street is long lost. The site was a gas station for several decades and then transformed to Giovanni's restaurant. Below is the same intersection looking east at the gateway to Brady Street. The house at left was razed for the widening. At right is a business known at various times as Triscari's, the Peacock, and the Dancing Ganesha. (Courtesy of the City of Milwaukee Department of Buildings and Bridges.)

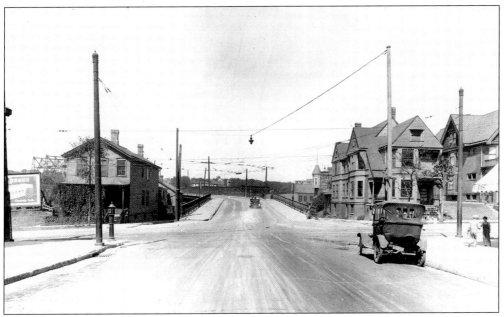

Here is the same intersection looking north over the Holton Street Viaduct. The dwelling at right has been razed. The home at left was also razed and is now the site of a neighborhood garden generously donated in 2007 by Mike and Mary Ellen Mervis. (Courtesy of the City of Milwaukee Department of Buildings and Bridges.)

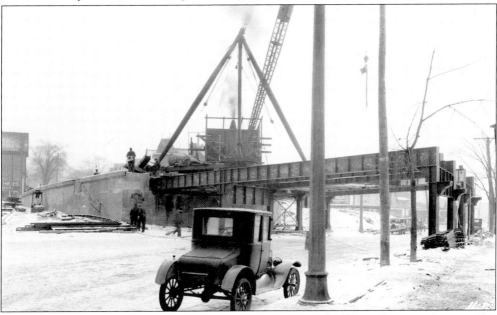

This photograph shows the reconstruction commencing at the Water Street underpass. The project created quite a controversy. One city engineer planned an approach that cut a swath through two residential blocks to lessen the incline of the bridge. Brady Street neighbors united against that design, and the plan that prevailed is the steeply inclined S curve bridge that stands today. See chapter 3 for more on the Holton Viaduct. (Courtesy of the City of Milwaukee Department of Buildings and Bridges.)

By the 1930s, much of Milwaukee's building stock, especially wood-framed structures, was quickly decaying. Many people had made the transition from horse and carriage to automobiles, leaving many neglected barns and carriage houses as well. The city took a photographic survey of substandard structures and ordered razing of condemned structures. This building stood at the northwest corner of Van Buren Avenue and Lyon Street. (Courtesy of the Milwaukee Public Library, Humanities Collection.)

Here is a photograph of a commercial building about to be razed that stood at the southwest corner of Kane Place and Sobieskie Street (now Arlington Place). Notice the faded old Pabst beer sign on the left. (Courtesy of Carl and Shirley Ferguson.)

Two

INDUSTRY LEADS THE WAY

In 1850, Byron Kilbourn, Milwaukee's west side founder and a man known for grand schemes, commenced to dig a canal to connect Milwaukee with Mississippi River trade routes. He also built the Kilbourn Dam to regulate water levels for shipping. The emergence of railroads rendered his plan financially unviable. What little of the canal that was dug was filled in and became Commerce Street. Soon the Milwaukee riverfront along Commerce Street became lined with factories to exploit Wisconsin's bountiful resources. Milwaukee was turning the corner from a trading post to an industrial powerhouse, and Commerce and Water Streets, adjacent to Brady Street, helped lead the way.

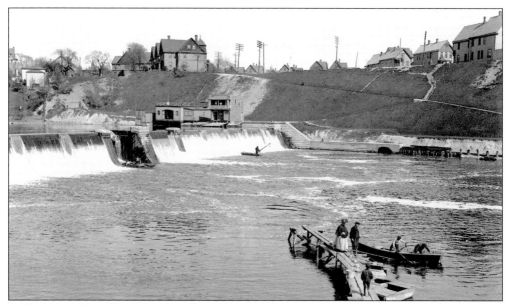

In the 1830s, the Kilbourn Dam and canal were built to help link Milwaukee with western ports. Railroads were invented, making canals obsolete. The canal was soon filled in and became Commerce Street, aptly named for the many factories erected on this riverfront strip. The dam remained, serving merely aesthetic use until the 1990s. The water below the dam became popular for fishing for the Polish residents of Brady Street. (Courtesy of the Milwaukee County Historical Society.)

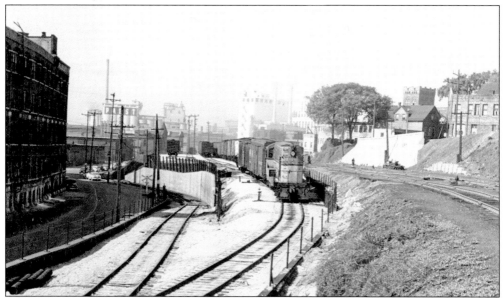

By the 1850s, breweries, tanneries, lumberyards, coal piles, and other industrial uses dominated the river valley along Commerce Street. The Milwaukee and Mississippi Railroad, later known as the Milwaukee Road, ran parallel to this stretch and terminated in a brewery warehouse at Highland Avenue, giving this line the nickname the "Beerline." This photograph shows a locomotive pulling a load eastward from the brewery warehouses in the distance. (Courtesy of Kalmbach Publishing.)

The railroad was a source of jobs for Brady Street area residents. This is Steve Jazdzewski posing on an old wooden boxcar. Jazdzewski must have really liked trains for this was taken years before he actually worked on the Beerline. During the Depression, rail workers "accidentally" kicked a few chunks of coal off the passing train near relatives who hid nearby. A coaster wagon full could heat the house on a blustery winter night. (Courtesy of Don Jazdzewski.)

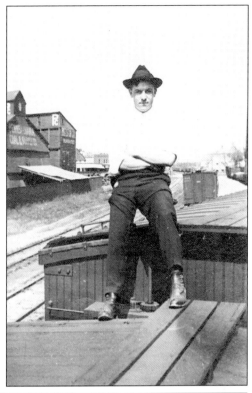

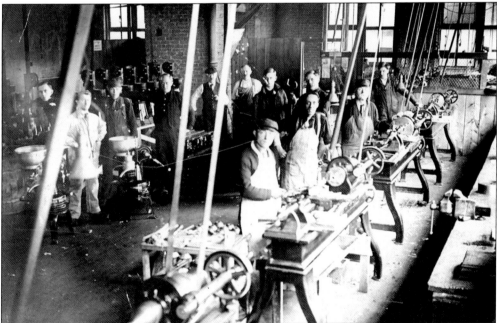

Work for Polish immigrants and their kids was not hard to come by, but the hours were long and the conditions barely tolerable. Frank Jazdzewski, a cousin to Steve above, found work in a plant where cream separators were manufactured. He is the young man standing directly behind the guy in the white apron and cap. (Courtesy of Don Jazdzewski.)

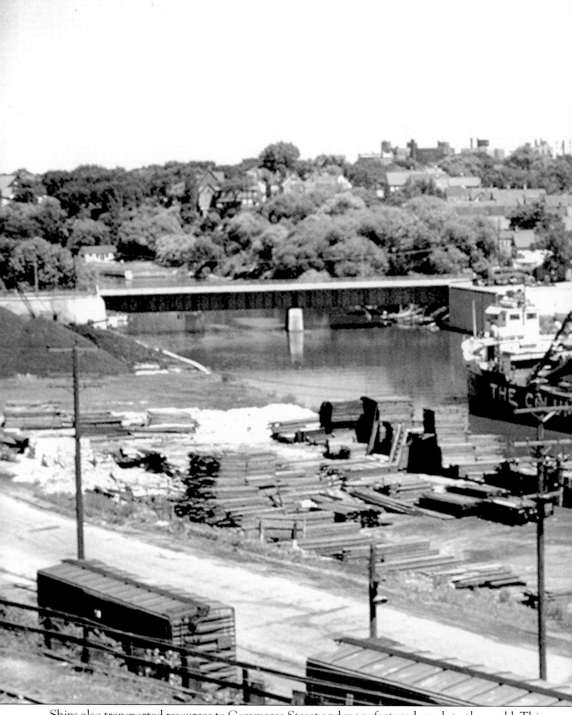

Ships also transported resources to Commerce Street and manufactured goods to the world. This photograph shows a ship unloading coal at the Humboldt Avenue bridge, a remarkable sight considering this is a valley of condominiums today. The coal was used for power plants and to

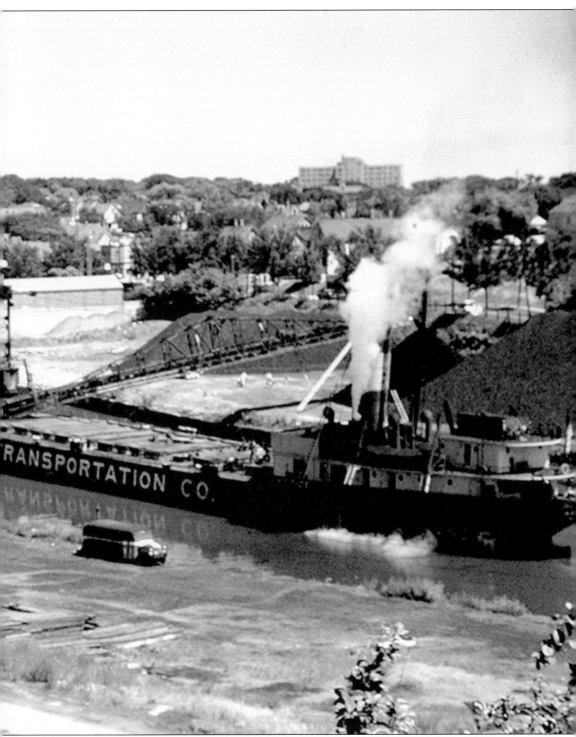

heat homes, businesses, and factories. In the foreground are railcars on the Beerline. At left in the distance is Caesar's pool and a comfort station. (Courtesy of the Fr. Frank Yaniak collection.)

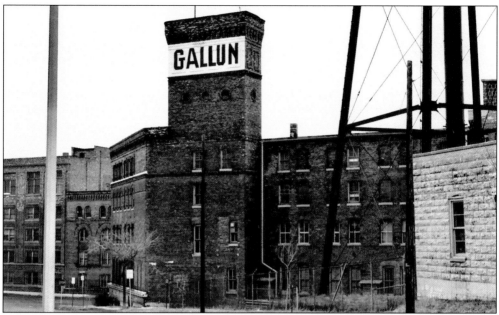

Tanneries need ample livestock for hides, access to hemlock trees for tannins in the bark, and a willing, cheap labor force. Milwaukee had all that in abundance and in the late 1800s led the country in tannery output. Tanneries were abundant on both sides of the Milwaukee River near Brady Street during this era. The Gallun Tannery lined both sides of Water Street just north of Brady Street. (Courtesy of Gail Fitch and the Jim Eukey collection.)

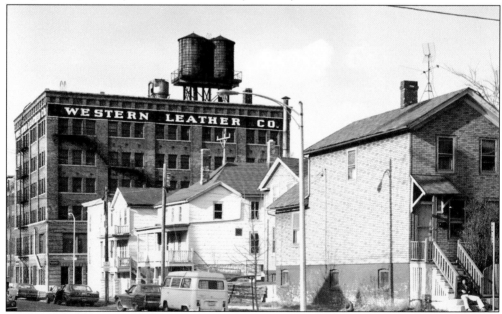

The Western Leather Company dominated one square block at Pearson and Marshall Streets. In the foreground are modest cottages erected by the workforce right in the factory's shadow, oblivious to the odors and noise that emanated from the plant. This particular company hired a lot of the Italians who lived around Brady Street. (Courtesy of the Milwaukee Public Library, Humanities Collection.)

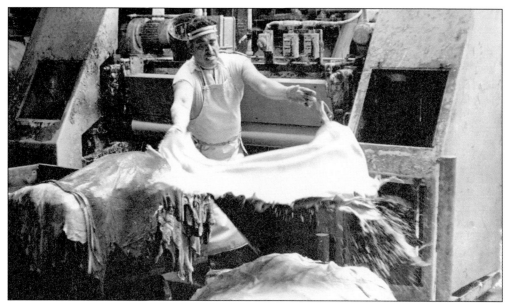

Tanning hides was no easy task as this Gallun Tannery photograph shows. The stench, the noise, and the long hours did not discourage the low-skilled laborers yearning for a better life. Census records from 1900 show nearly 50 percent of Brady Street area Polish residents worked in the leather industry. They were followed almost in perfect succession by immigrants from Italy, then Puerto Rico, and later African Americans from the South. (Courtesy of the Milwaukee Public Library, Humanities Collection.)

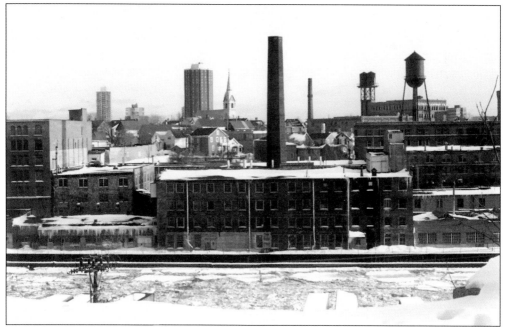

The Brady Street area's skyline was dominated by the smokestacks and water tanks of heavy industry even into the 1980s, as this panorama from across the Milwaukee River shows. Today this same view would show a canyon of condominiums. (Courtesy of Gail Fitch and the Jim Eukey collection.)

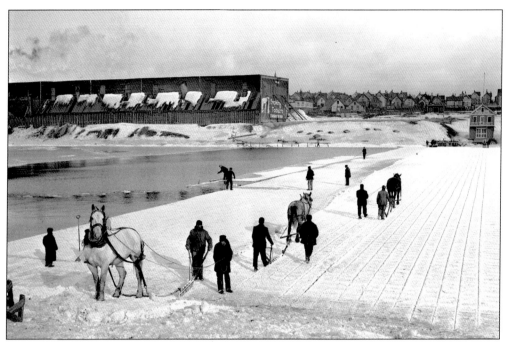

Not all neighborhood industry took place in oven-baked sweatshops. Before refrigeration, food was stored in iceboxes, and the ice was procured right from the frozen Milwaukee River, as well as some inland lakes. Wisconsin sent its ice by railcars insulated with straw all over the county. Horses pulled cutting plows in a grid pattern across the river, and workmen chopped the blocks free. The ice blocks then were sent up a conveyor into a storage shed. The photograph above shows a storage shed in the background. The sheds, including some owned by local breweries, were common on both sides of the river. (Courtesy of the Milwaukee Public Museum Sumner W. Matteson Collection.)

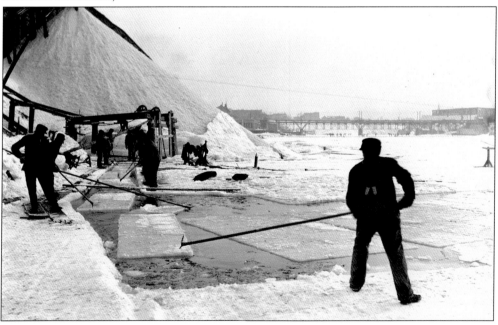

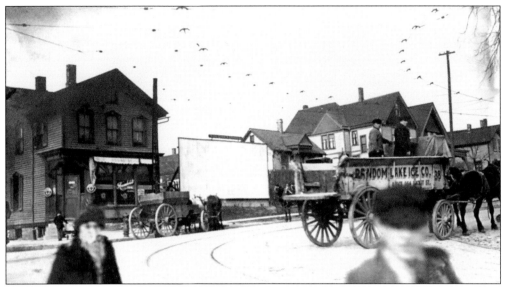

While manufactured goods were sent near and far by ship and rail, local deliveries went to shops and homes via horse-drawn wagon. The wagon on the right came from the Random Lake Ice Company, which had a shed on the Milwaukee River. A placard posted in the window of a home signified the weight of ice block requested. This photograph is looking toward the northwest corner of Humboldt and North Avenues. The shop on the left was razed and is now a gas station. (Courtesy of the Milwaukee County Historical Society.)

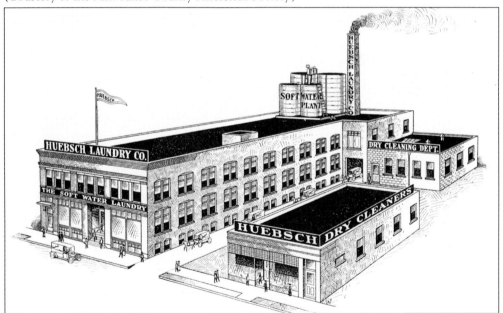

The Huebsch Laundry Company was the only industrial plant on Brady Street. It moved here from Wausau in 1914. The company was a pioneer in the development of household and commercial washers and dryers and was a source for jobs for many Brady Street area women. Vacated in 1973, the plant was finally razed in the early 1990s for the Passaggio, a complex of shops and housing that helped lead a renaissance on Brady Street. (Courtesy of the Milwaukee Public Library, Humanities Collection.)

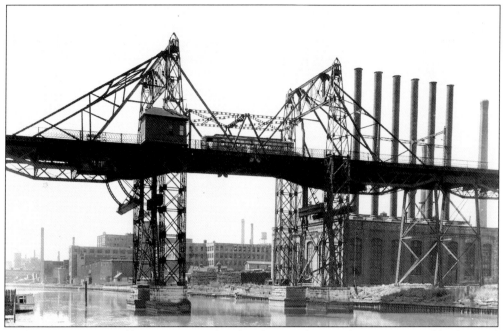

With its many river valleys to span, Milwaukee became known for its variety of bridges and long-spanning viaducts. Several link the Brady Street neighborhood with adjacent neighborhoods. Van Buren Street and Holton Street were first linked by a viaduct (a long continuous bridge) in 1892. With its S curve, steep incline, and lift to accommodate ships, the Holton Street Viaduct was quite an imposing sight, and the steel truss framework made it fit in well with the industrial structures below. Notice the No. 14 streetcar crossing in this photograph and the power plant at right that now houses the Lakefront Brewery and Palm Garden. (Courtesy of the Milwaukee County Historical Society.)

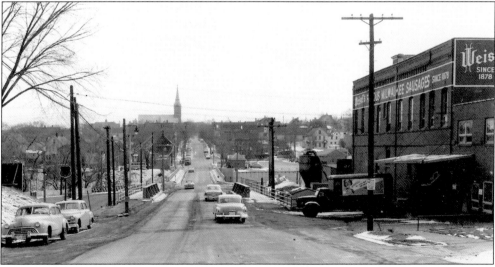

Here is a view from across the Humboldt Avenue bridge looking toward Brady Street with St. Hedwig's steeple prominent on the horizon. To the right is another plant that provided jobs to locals, the Weisel's Sausage Company, which was established in 1878. The plant was recently razed for a condominium development. (Courtesy of the Milwaukee County Historical Society.)

Three

LAKE MICHIGAN AND THE GOLD COAST

Lake Michigan is Milwaukee's most precious asset. Its waves—often gentle but sometimes furious—have chiseled the bluff below what is now Prospect Avenue for thousands of years. In the 1850s, the Chicago and North Western Railroad was built at the base of the bluffs to carry passengers and freight to and from the expanding city center. Today the railroad right-of-way survives as a bike trail. Several landfill projects below the bluffs have added space for roads and parkland along the lakefront. Atop the bluff, German and Yankee industrialists erected palatial mansions, taking advantage of the spectacular lake views. Long before suburban sprawl, Prospect Avenue around Brady Street was considered the heart of Milwaukee's "gold coast."

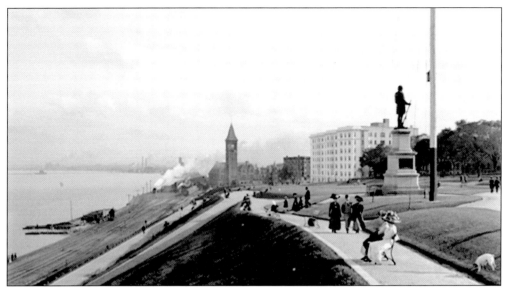

Lake Michigan once met Milwaukee at the base of the bluff. In the distance is the Chicago and Northwestern rail station, and at left are the tracks that ran along the base of the bluff. Milwaukeeans, especially east side well-to-do, enjoyed a stroll through Juneau Park to watch ship and train activity and the calming waves. The white building is the Cudahy apartments before the tower addition. The statue at right is of Milwaukee's original permanent settler, Solomon Juneau. (Courtesy of the Milwaukee Public Museum Sumner W. Matteson Collection.)

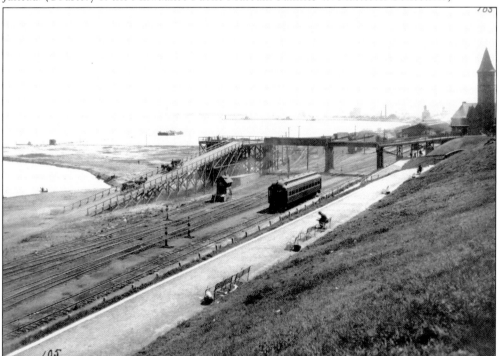

In 1917, a bridge and ramp were built, and wagonloads of fill were hauled over the railroad tracks to create parkland along the lakefront—today's Veteran's Park and lagoon. (Courtesy of the Milwaukee Public Museum Sumner W. Matteson Collection.)

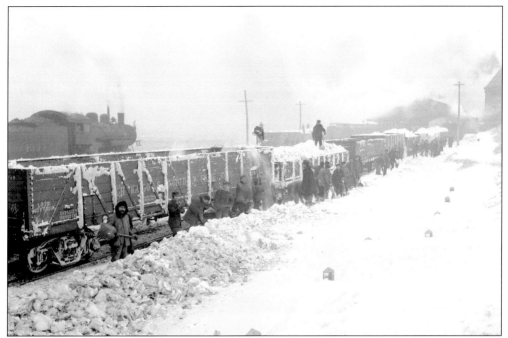

Here is another rail view along the lakefront. Laborers remove snow and ice from a blocked track while a steam locomotive blows by on the southbound track to the east. (Courtesy of the Milwaukee Public Museum Sumner W. Matteson Collection.)

Beyond the sandlot field stands the Milwaukee Metropolitan Sewerage District's pump house. Freshwater from Lake Michigan was pumped from this house, built by the Edward P. Allis Company in 1888, through a tunnel under East Kane Place and then flushed the Milwaukee River at a rate of 500 million gallons a day. The river had become a stagnant pool of industrial waste and human refuse. The project had a lot of doubters, but its success is said to have saved the east side. This engineering marvel survives as an Alterra coffee shop. (Courtesy of the Milwaukee Public Museum Sumner W. Matteson Collection.)

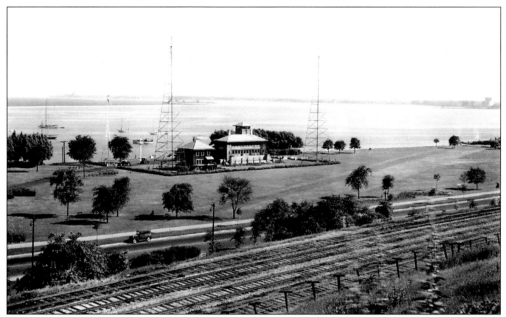

This view, taken from the backyard of a home on Prospect Avenue, shows the United States Coast Guard station shortly after being built. This prairie-style station, built in 1915, is on the National Register of Historic Places and is one of only two that survive—the other is in the Philippines. There have been many attempts to revive it under new uses, but it is now slated for demolition. (Courtesy of the Milwaukee County Historical Society.)

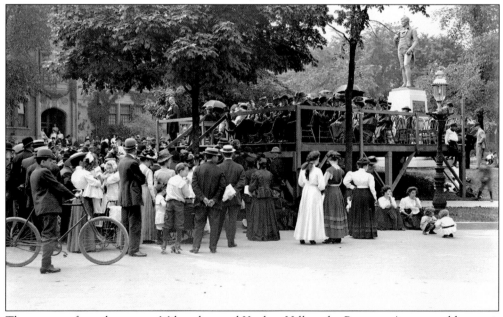

The gateway from downtown Milwaukee and Yankee Hill to the Prospect Avenue gold coast is Burns Triangle, a small park. A contingent of Scottish descendants from these neighborhoods erected a statue to honor the Scottish poet and folk hero Robert Burns. This picture shows the statue's 1909 dedication, which over 2,000 people attended. (Courtesy of the Milwaukee Public Museum Sumner W. Matteson Collection.)

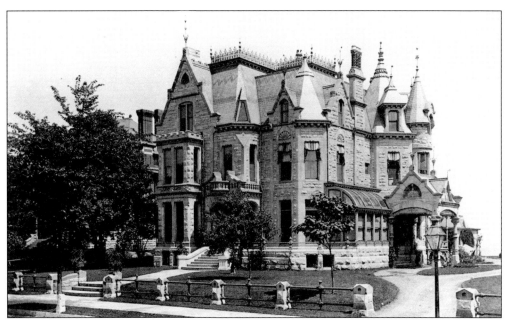

Charles Ray had prominent Milwaukee architect Edward Townsend Mix build this mansion a century ago at 1410 North Prospect Avenue. Ray came from New York and earned his riches as a grain commissioner, president of the National Exchange Bank, and treasurer of Northwestern Mutual Life. The home was torn down in the 1940s. (Courtesy of the Milwaukee County Historical Society.)

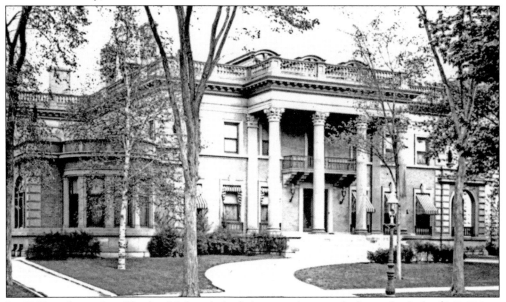

In 1903, industrialist Charles McIntosh had this neoclassic-style home built for $140,000 at 1584 North Prospect Avenue. Only the finest and most expensive materials available were used in the 22,000-square-foot mansion. After McIntosh's death, his widow sold it to linseed oil heir William Osborne Goodrich. In 1932, the Goodrich family moved to Fox Point, and the Wisconsin Conservatory of Music later moved in. (Courtesy of the Wisconsin Conservatory of Music.)

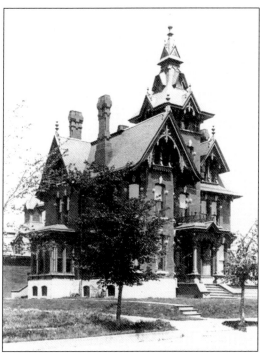

Prospect Avenue was settled by factory owners and wealthy professionals who built palatial mansions rivaled only by those on Grand Avenue (now West Wisconsin Avenue). No expense was spared by these captains of industry. Even more remarkable might be the contrast with tiny cottages built by factory workers just a block or two to the west. (Courtesy of the Milwaukee County Historical Society.)

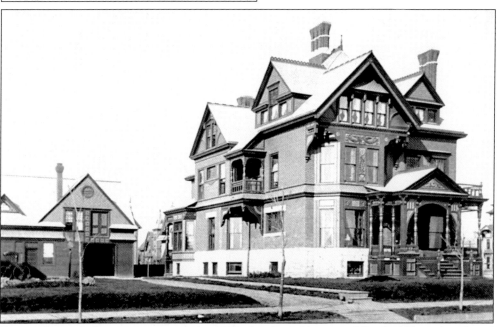

During the city's dirty-water crisis in the 1880s, brothers Alonzo and Sanford Kane distributed freshwater from a natural spring on their land near what is now Oakland and North Avenues. Their generosity was rewarded with a street named after them. The Kane brothers also owned a hotel in the area and eventually built mansions on Prospect Avenue across the street from each other. The Sanford Kane residence at 1841 North Prospect survives and is considered Milwaukee's finest remaining example of Queen Anne–style architecture. (Courtesy of the Milwaukee County Historical Society.)

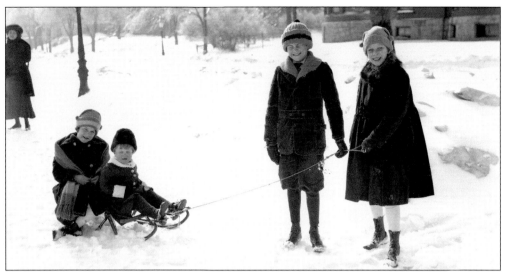

Unidentified children enjoy sledding in their yards down to the lakefront. Life was very different for children of the more affluent compared to the immigrant children north of Brady Street. Newspapers of the day wrote of the "swill children" who foraged in the trash of rich residents on Prospect Avenue, presumably for scraps to feed their animals. (Courtesy of the Milwaukee Public Museum Sumner W. Matteson Collection.)

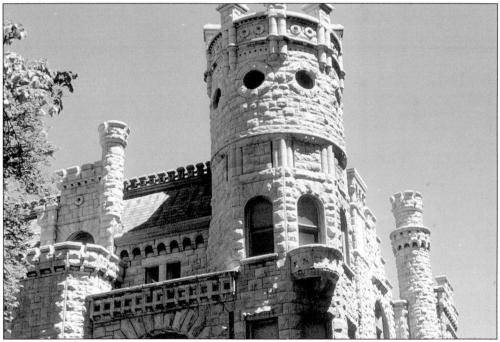

The Benjamin castle stood at 1570 North Prospect Avenue. David Benjamin came from Maine to Michigan and partnered in the lumber business. He later came to Milwaukee and had this home built. This photograph was taken just days before the home was razed for the Newport Apartments in 1957. Most of the Prospect Avenue gold coast mansions have been removed for high-rises—a new brand of gold coast. Those that have survived have mainly found institutional uses. (Courtesy of the Fr. Frank Yaniak collection.)

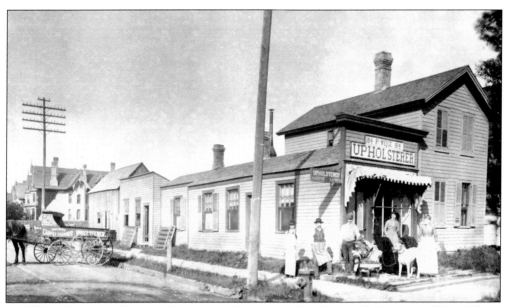

Paul Weise Furniture Company has been in business on North Farwell Avenue and East Albion Street since 1886. Weise began as an upholsterer and expanded to fine furniture. (Courtesy of Paul Weise.)

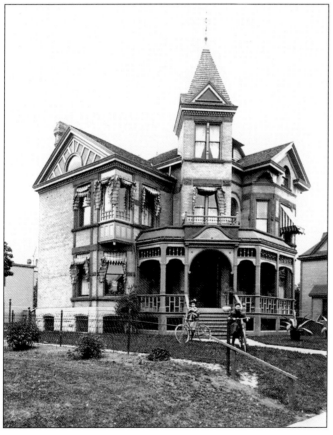

The area south of Brady Street has many ornate homes and even mansions of its own. Apparently not every person of wealth desired a lake view. Edwin Roberts, a prominent local mason contractor, built this Victorian Italianate home at 1020 East Kewaunee Street in 1888. Some neighbors affectionately call it the "Addams Family house." It has recently been restored to its former glory. (Courtesy of the Milwaukee County Historical Society.)

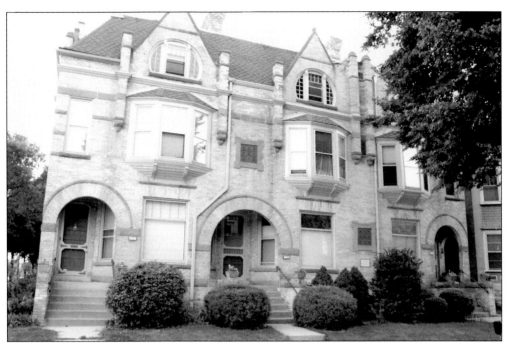

Row houses are more common in Europe or on the East Coast than in Milwaukee, but the area south of Brady Street has several fine examples. Mason contractor John Graham built this three-unit row house of cream brick as an investment property in 1887. The building is at 1501–1507 North Marshall Street and is on the National Register of Historic Places. (Author's collection.)

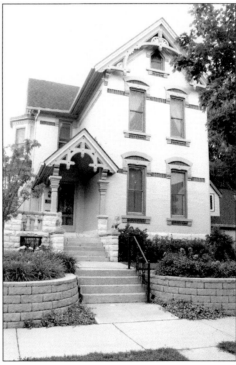

This stately Victorian Italianate house at 1661–1663 North Astor Street was built by prominent local architect Henry Messmer in the late 1880s for Phillip Hartig. Messmer also designed St. Hedwig's Church, among other local landmarks. Hartig was a German army officer before immigrating to Milwaukee. He was an executive for the Schlitz Brewing Company and later owned a lumber company. The building, as well as its carriage house, has recently been remodeled and divided into condominiums. (Author's collection.)

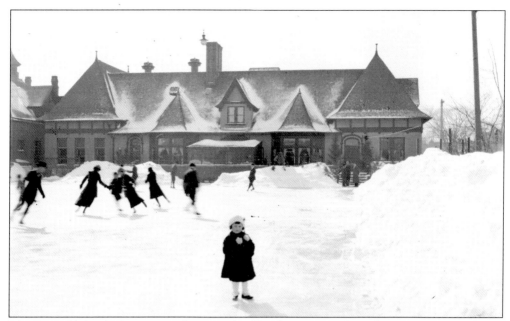

The Town Club, which once stood just south of Brady Street on Farwell Avenue, is an exclusive club catering to residents of the gold coast. It offered a restaurant and hall, as well as activities like tennis and squash. In the summer, outdoor concerts and plays were featured. The tennis court was flooded in winter for skaters as this picture looking south from Brady Street shows. (Courtesy of the Town Club.)

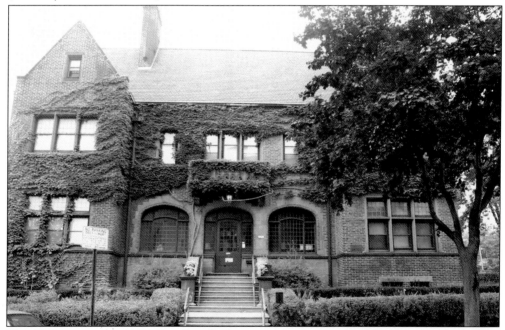

This Tudor mansion at 1630 East Royall Place was built by Charles Allis, first president of the Allis Chalmers Corporation. It was designed by prominent local architect Alexander Eschweiler. Allis was a fine art collector, and the mansion was willed to the City of Milwaukee to be used as an art museum. (Author's collection.)

Four

POLISH PERSEVERANCE

Once natural resources were harnessed and factories along the Milwaukee River had proliferated, only one part of the equation remained—that of human labor. Simultaneously, an unsuccessful revolt in Prussian Germany (now Poland) by peasants with little hope for a better lot in life created ample incentive for thousands to immigrate to places like Milwaukee. They rolled up their sleeves and readily toiled long hours in filthy and hazardous conditions with an eye on a better life—if not for themselves, then for their children. The Poles squatted on previously forgotten marshland north of Brady Street not far from the din and sooty haze of their workplaces. The earliest settlers erected tiny houses of recycled materials on stilts over the soggy soil. More established south side Poles dubbed the area the "Koza Dory," Polish for goat yard, for the goats, chickens, pigs, and even cows kept in the crowded enclave. The Koza Dory was a stark contrast with the gold coast just a block or two away. But compared to the conditions across the sea, paradise was found indeed.

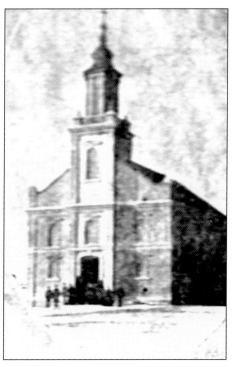

After years of enduring long treks to Polish-speaking parishes on the south side, Brady Street Polish immigrants finally met on the feast of St. Hedwig on October 17, 1871, and established a parish of their own. They raised $11,000 and built a modest church out of recycled materials. In 1886, the present cream-brick landmark was built, and its 162-foot steeple remains Brady Street's most prominent landmark. This picture (below) is from 1953. Cream brick is porous and readily takes on coal soot and other pollutants, giving the church a dark gray appearance. Notice the lack of traffic signals at this now crowded intersection. (Left, courtesy of Three Holy Women Parish; below, courtesy of the Fr. Frank Yaniak collection.)

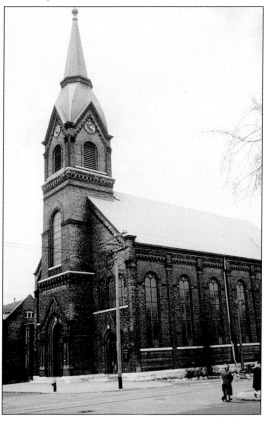

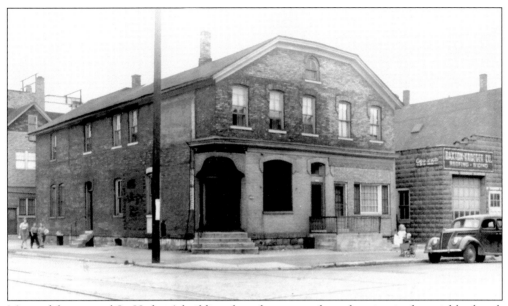

Many of the original St. Hedwig's buildings have been moved to other sites in the neighborhood, finding new uses. This was the original school building. It was won in a raffle and then sold to Joseph Polczynski for $50. He moved it two blocks east and made it a tavern. This versatile bar was the Iron Inn in the 1950s, then Shenanigan's in the 1980s, and is now the Hi-Hat Lounge. (Courtesy of Three Holy Women Parish.)

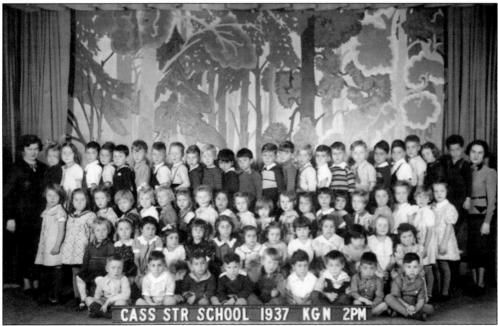

This 1937 photograph shows the very first kindergarten class of Cass Street School. A public school stood at Cass and Pleasant Streets starting in 1868. In 1904, the present building was built and named Cass Street School. A rift developed between Polish families who chose St. Hedwig's Catholic School for religious and cultural reasons, and a group who favored the benefits of the more Americanized and ethnically mixed Cass Street School. (Courtesy of Don Jazdzewski.)

For Polish immigrants, land and home ownership were unfathomable in their homeland. One *Milwaukee Sentinel* reporter in 1874 noted that "despite their low incomes, Poles have a strong prejudice against paying rent . . . usually the first money they earned is put into buying a lot on which to erect a house as soon as possible. Before long a bedroom or an entire upper floor were added." Suddenly they were landlords, and they had space to take in family and friends from the old country. (Courtesy of the City of Milwaukee Departement of Buildings and Bridges.)

Early homes were often constructed of recycled material from teardowns in more affluent areas. Most were built on wooden stilts over the marshland north of Brady Street. Another way to modify a home was to eventually jack it up with screw jacks and add a basement unit. The raised cottage came to be known as the "Polish flat," of which there are many variations. (Courtesy of the Fr. Frank Yaniak collection.)

There was yet another source of Brady Street area housing stock: homes moved from other locations. At 1750 North Humboldt Avenue stands a home built in 1847—one of the city's oldest. Milwaukee was just one year old when George Austin built this house on Jefferson Street and Wisconsin Street. It was purchased by Teofil Czerwinski and pulled by horses over rolling logs to its new site. This photograph shows it before the move. (Courtesy of the Milwaukee County Historical Society.)

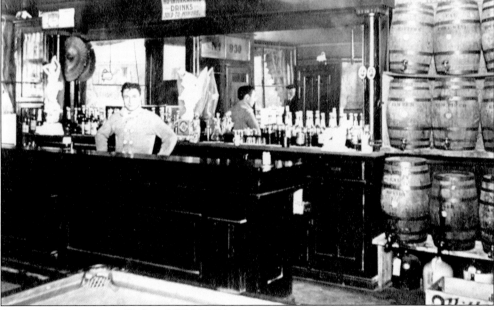

Anyone who sports an "I closed Wolski's" bumper sticker is surely familiar with this tavern. It is one more example of a building on the move. It was originally a dry goods store on Brady Street. After a fire, Bernard Wolski moved the building to Pulaski Street in 1907, and it is now run by the fourth generation of Wolskis—the longest stint for a family-owned tavern in the city. (Courtesy of the Wolski family.)

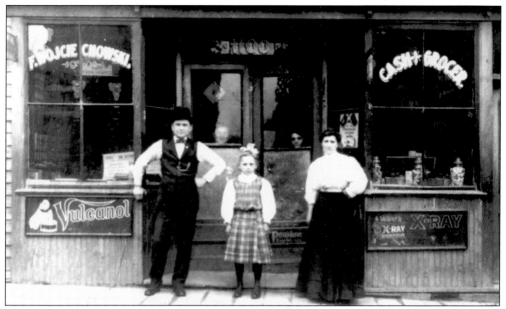

Frank Wojciechowski, who owned a grocery on what is now East Kane Place at Pulaski Street, was one of the earliest entrepreneurs for the Polish enclave north of Brady Street. Brady Street itself consisted mainly of German- and Yankee-owned stores. Due to language and cultural barriers, Poles opened their own shops, dotted throughout their neighborhood to the north. (Courtesy of the Milwaukee County Historical Society.)

In 1909, University of Wisconsin sociologist Edward Allsworth Ross did a study on the growing numbers of unemployed in Milwaukee. His research included this photograph looking north on Pulaski Street toward Kane Place. It includes an idle father looking after 12 children. (Courtesy of the Wisconsin State Historical Society.)

This view looking south on Pulaski Street shows several children at play. The buildings at the immediate left were torn down to create Pulaski Playground. The abundance of rear cottages wiped out any hope for yard space, so children often played in the street. The playground was the result of an effort by alderman John Suminski in 1924. (Courtesy of the Milwaukee County Historical Society.)

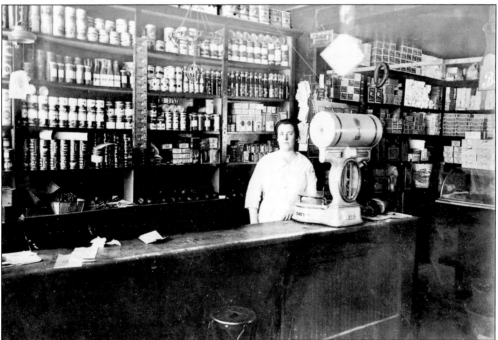

A step inside the store in the previous picture in 1919 reveals the interior of Janowski's grocery store. Cora Janowski stands behind the scale ready to serve. Most of the stores in the Polish village were referred to by the last name of the owner. (Courtesy of Lorraine Janowski.)

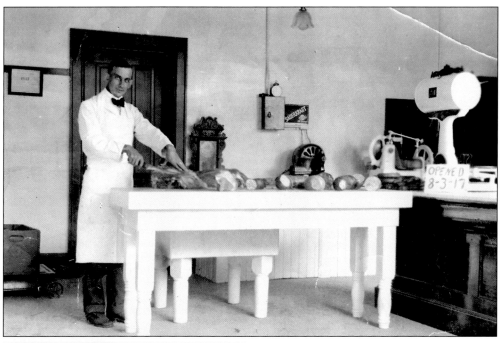

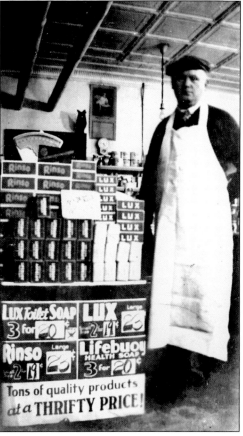

Frank Czaja proudly carves a ceremonial slice on the opening of his meat market at 1843 North Pulaski Street in 1917. Frank's daughter Viola and her husband, John Tutkowski, took over under the Tutkowski name in 1924 until the closing in 1966. Frank's son, John Czaja, and Frank Jr. used their training and established the popular Milwaukee Boiled Ham Company. At left is John Tutkowski alongside his Lux soap display. (Courtesy of Linda Jung.)

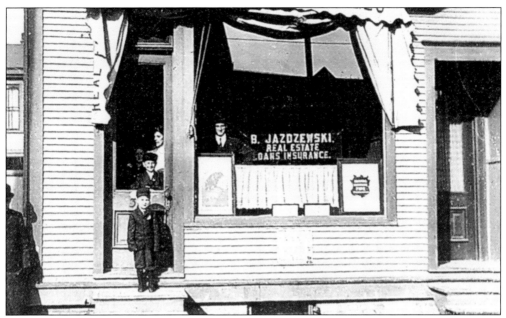

Boleslaus Jazdzewski once sold steamship tickets in Poland to aspiring United States citizens. Eventually he bought one for himself and made his way to Brady Street. He started Jazdzewski Building and Loan at 1208 East Brady Street (above). He was influential in helping immigrants start a savings account—if even just a penny at first—obtain insurance, and eventually purchase homes. His first shop was 1208 East Brady Street, the present site of Brewed Awakenings. The business later became Peoples Building and Loan and moved to 1205 East Brady Street, the present site of Cempazuci restaurant. Below, an unidentified insurance agent jokes with young Robert Jazdzewski. (Courtesy of Don Jazdzewski.)

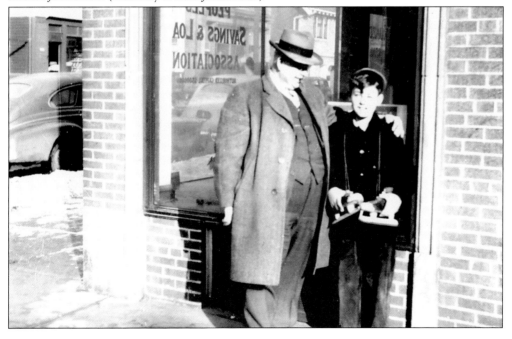

The Charles Sikorski building, constructed in 1875 at 1200 East Brady Street, is the oldest surviving commercial building on Brady Street. It is now Brady Street Futons. Sikorski, with his saloon and dry goods shops, as well as a second-floor rooming house, was a pioneer for Polish shop owners, who soon became more prevalent on Brady Street. (Courtesy of the Fr. Frank Yaniak collection.)

The building at left is Mike's Café, owned by Mike Stankiewicz, at 1216 East Brady Street. At right is the Suminski Funeral Home. John I. Suminski started as an undertaker in 1905. The family is still in business, although it recently moved off Brady Street after a 100-year run. In the mid-1900s, Stankiewicz and his wife raised 10 children in the upper flat, and the Suminskis had eight of their own. (Courtesy of the Fr. Frank Yaniak collection.)

Michael Sajdak sold and repaired shoes from this shop at 1217 East Brady Street. In true mom-and-pop shop fashion, Sajdak would run down from his upper flat when neighborhood customers rang the bell. His sons later ran the business, and Stan's Bootery, a popular south side shop, is an offshoot. This is one of several residential buildings on Brady Street in which the first floor was converted to commercial use. (Courtesy of the Fr. Frank Yaniak collection.)

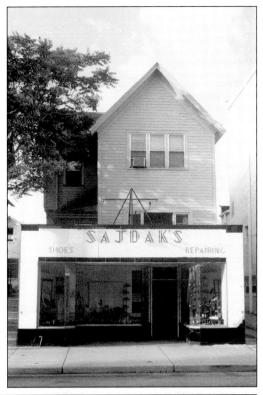

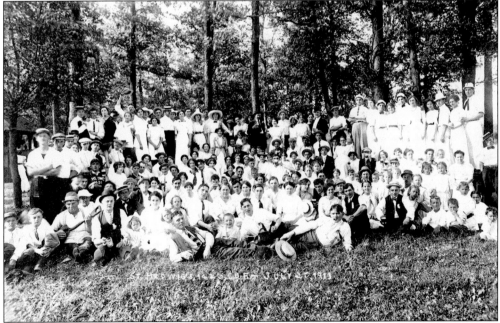

Very few of these folks had cars, so the interurban streetcar must have gotten a workout when St. Hedwig's had group outings. This is the Catholic Order of Forrester's annual picnic in 1913. It was most likely held in Shooter's Park, near the armory in Shorewood. (Courtesy of Don Jazdzewski.)

Mania Stromowski takes a look at her new surroundings in this 1904 photograph. For immigrants, life's hardships seem bearable through the hope of a better life for their children. This view looks west down Kane Place from Warren Avenue. Notice the commercial building on the northwest corner where the Arlington Court apartment tower now rises. (Courtesy of Carl and Shirley Ferguson.)

The trend of large Polish families steadily lessened by the second and third generation. Someone forgot to tell John and Mary Jane Rozwadowski of Warren Avenue. Here is the lineup at the family's "annual" christening in 1958. From left to right are Mary Jane and baby Philip, Cora Sue, Tom, Jim, Tim, Mary Kay, Jane Frances, Lori Ann, Patti Jo, and La Rae. Yet to come were Julie Renee, Dore Marie, and Nick, who made lucky 13! (Courtesy of the Fr. Frank Yaniak collection.)

Five

ITALIAN SPICE IN THE NEIGHBORHOOD STEW

Italians, specifically from the downtrodden south of Italy and especially Sicily, began populating the Third Ward directly south of downtown Milwaukee in the 1890s. Many found a niche in the produce business, while others labored for railroads, in city labor jobs, and for various local factories. The Third Ward housing stock began to deteriorate, and overcrowded conditions caused a spillover of Italians to the north of downtown. Jackson Street south of Brady Street became the epicenter of this new enclave, and it soon spread to the west end of Brady Street, where Italian mom-and-pop shops and restaurants continue to thrive. Brady Street's "Little Italy" grew to a peak in the 1950s; Humboldt Avenue was the unofficial border between the Italians and Poles of Brady Street. Both groups primarily shopped in their own stores and worshipped in their own churches, but the cultures gradually mixed, giving Brady Street a uniquely blended character.

An 1890s *Milwaukee Sentinel* reporter described the latest immigrant group to settle in the city as the "tawny children of the sunny land of art." The statement referred, of course, to an Italian influx, and this new group certainly brought a flash and attitude not familiar with the more stoic northern and eastern Europeans who came before. Ray Besasie, cruising Van Buren Street in his 1929 Pierce Arrow, certainly reinforced that sentiment. That is Ray Jr. in the passenger seat, living large. (Courtesy of the Italian Community Center–Milwaukee.)

Children of the Ray family pose in front of their home at 1602 North Jackson Street. From left to right are Nick, Lena, Augie, Mike, and Marie. Gloria Ray is hiding behind the porch after perfectly posing all her children save little Augie. The family's surname was Re in Sicily but got mangled like so many other names thanks to Ellis Island translations. (Courtesy of Augie Ray.)

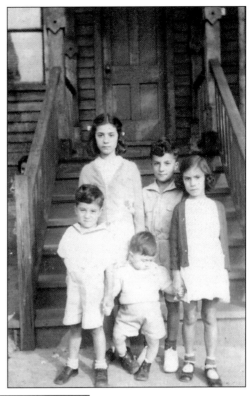

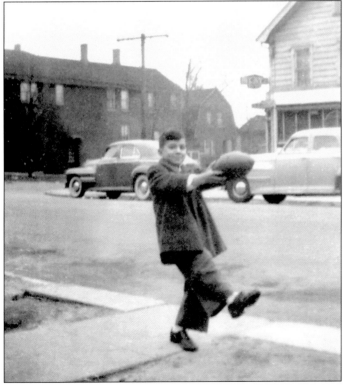

A few years later, in November 1945, nine-year-old Augie Ray makes a pose that must have made Gloria proud. In the background is Fazio's restaurant (more recently Joey's), considered Milwaukee's quintessential Italian eatery and drawing customers from the whole area. Augie and other neighborhood kids shoveled snow away from the fancy cars of patrons for loose change. (Courtesy of Augie Ray.)

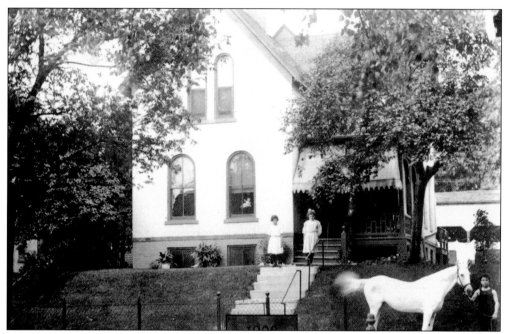

Frank Pastorino made a good living in the produce business on Broadway Street in the Third Ward. He moved his family to 1640 North Jackson Street. The house looks today much as it did in this 1908 photograph, without the family horse of course. Notice the infant being held in the window. (Courtesy of the Italian Community Center–Milwaukee.)

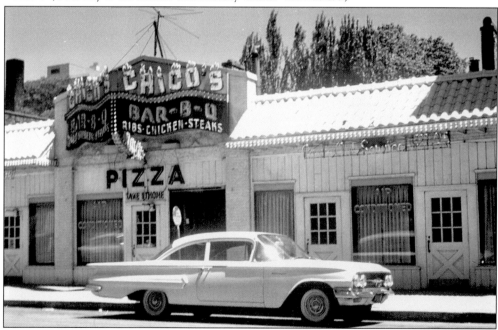

Chico's on Farwell Avenue was another popular Italian-owned eatery. Owners Frank and Angeline "Babe" LaGalbo blew smoke from the rib cooker out onto Farwell Avenue, compelling unsuspecting diners in for a bite. At bar time, Chico's often had a line down the block. One may recognize it as the present site of Majaraja Indian restaurant. (Courtesy of the Fr. Frank Yaniak collection.)

Jim D'Amato holds Jim Jennaro at gunpoint in an era where such play was less taboo. This is the corner of Jackson and Pleasant Streets with Dentice's meat market in the background. (Courtesy of Augie Ray.)

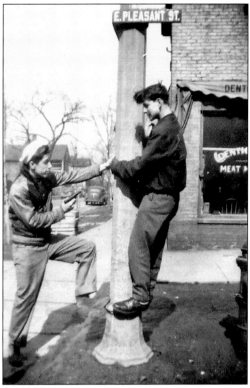

While not at play shooting guns, east side Italian teens were safe at Cass Street Playground . . . shooting craps. Tom Ferrara, Joe D'Amato, and John Zovi are in the mix; the others are unidentified. (Courtesy of Augie Ray.)

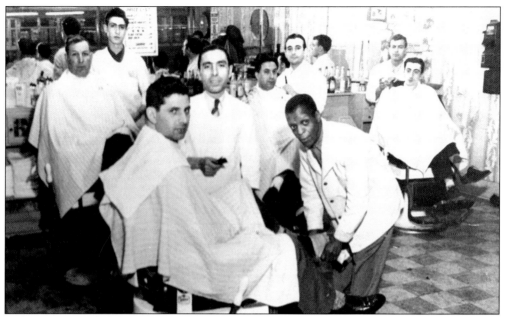

Welcome to Frank Bolzano's barbershop at Ogden Avenue and Franklin Place. It has been said that every local Italian barber worth his salt got his start at Bolzano's. The barbers from left to right are Peter LaBarbra, who moved on to cut hair on Brady Street for over 50 years; Frank Bolzano, cutting John Maio; Nick D'Amato, cutting Peter D'Amato; and Ralph Yob, cutting Jim Zingale. The shoe shiner is unidentified. (Courtesy of the Italian Community Center–Milwaukee.)

Joseph Bellante came to Brady Street via Brooklyn, New York, and he ran a shoe repair business at the southwest corner of Humboldt Avenue and Brady Street for over 30 years starting in the late 1940s. Bellante's was also a hangout for Sicilian compatriots who lingered around the radiator in winter and out on the stoop during the summer, where lively discussion in Italian added to the rhythms of the street. (Courtesy of Joseph Bellante Jr.)

This is not a scene from *The Untouchables.* Rosario Lo Menzo, brother of owner Jean Lo Menzo, proudly displays their sale price in this late-1940s photograph. Lo Menzo's clothing and haberdasher was at 1027 East Brady Street. (Courtesy of the Italian Community Center–Milwaukee.)

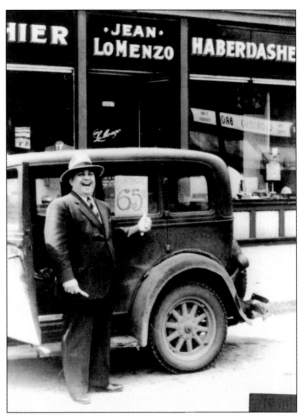

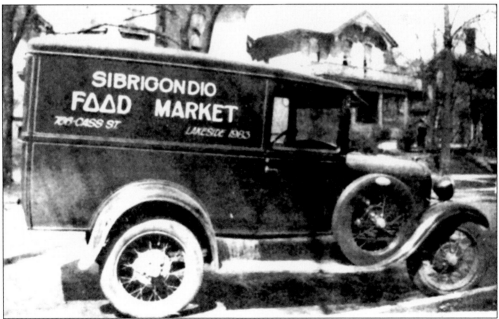

Jack Sibrigondio's food market started on Cass and Pleasant Streets, as his delivery truck shows. He later moved farther north to Brady Street to the building that has housed Sciortino's Bakery since 1948. (Courtesy of Nancy Sibrigondio Bushman.)

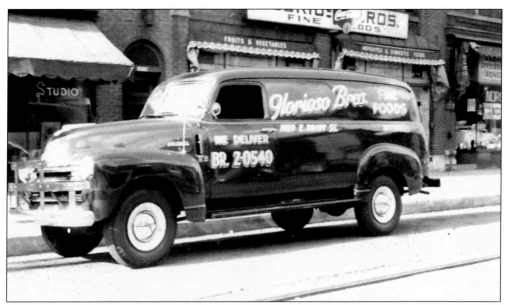

On the subject of delivery trucks, this 1948 Chevrolet is the first new truck owned by Glorioso Brothers. The brothers opened their shop that same year during a large movement of Italian-owned businesses to Brady Street. (Courtesy of the Glorioso family.)

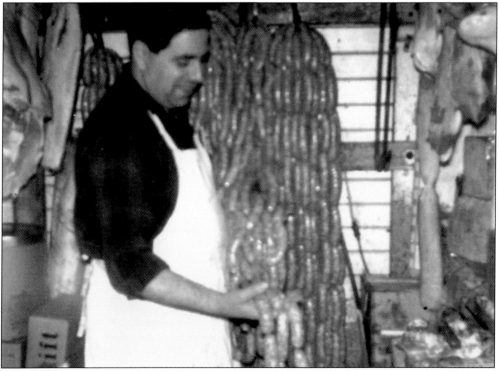

In 1960, Joe Glorioso shows off a string of fresh Italian sausage links that help make the family shop a local icon. If the countless links served by the Glorioso family these past 60 years were strung end to end, it would be interesting to see just how far they would stretch. See chapter 8 for more on the Gloriosos. (Courtesy of the Glorioso family.)

In 1906, Peter and Salvatore Dentice opened a meat market at the northeast corner of Jackson and Pleasant Streets. Their sons, Anthony and Peter, helped around the shop as children and later took over, continuing a run of over 100 years before closing in 2007. In the final years, they sold strictly sausage from the shop, which felt like a Streets of Old Milwaukee museum set. From left to right are Anthony Dentice, neighbor Frank Lanza, and Peter Dentice. (Courtesy of Frank Lanza.)

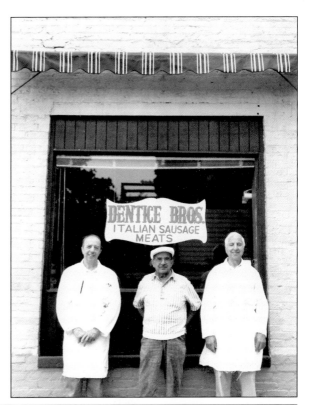

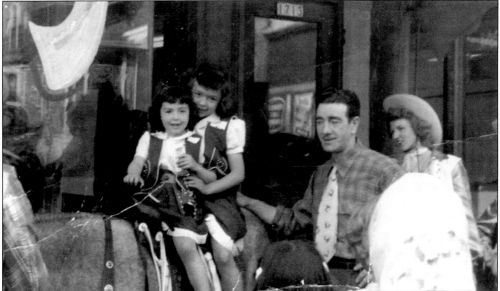

Another pair of brothers who owned a popular Italian grocery was John and Tony Seidita, who learned the trade from their uncle Jack Sibrigondio. They had a shop at 1711 North Farwell Avenue—now the site of the Kinko's parking lot. Tony was the butcher, and John specialized in artful displays of canned goods and groceries. This photograph was taken at the 1950 grand opening. John Seidita looks on as his daughters Sandra (left) and Barbara enjoy a pony ride. (Courtesy of Barbara Overstreet.)

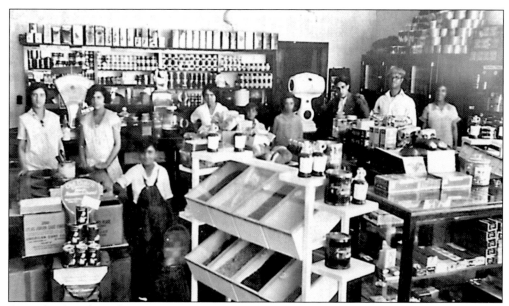

One of Milwaukee's finest restaurants is Sanford, run by award-winning chef Sandy D'Amato. This cozy eatery is nestled at the southwest corner of Jackson and Pleasant Streets. This is the same building in which Sandy's grandparents Joe and Kathryn D'Amato owned a grocery. From left to right are siblings Nina, Stephanie, and Salvatore D'Amato (Sandy's father). Next are Kathryn, three customers, and Joe D'Amato, as well as Kathryn's sister Ann. (Courtesy of Sandy D'Amato.)

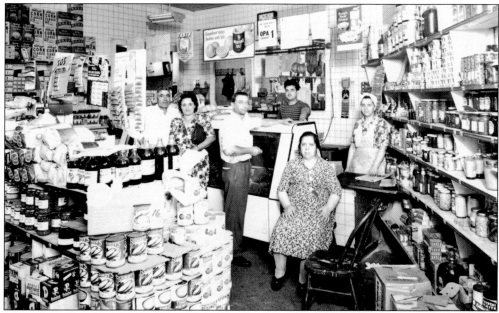

There seemed to be a family grocery on every corner in the days before mega-marts dominated. Family portraits taken in the shops seem to be a requisite. Perhaps it was the only place to find these hardworking folks in one place. Here is Frinzi's market on Water and Broadway Streets. From left to right are three unidentified customers, Joe Frinzi, Rosalia Frinzi, and Mary Frinzi, who later married Joe Glorioso. (Courtesy of the Italian Community Center–Milwaukee.)

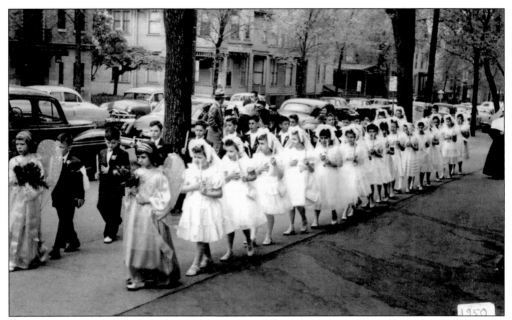

A communion march takes place in 1950 down Pleasant Street alongside St. Rita's Church as these youngsters prepare to enter the church for the ceremony. St. Rita's was formed in 1925 as a satellite mission of the Italian church in the Third Ward, Our Lady of Pompeii, as the Italian community grew north of downtown. The church was completed in 1938 and featured masses in Latin and Italian until recent years. (Courtesy of the Italian Community Center–Milwaukee.)

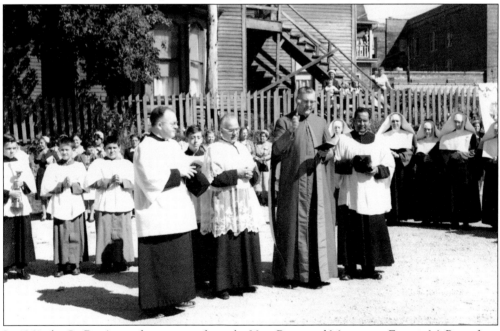

In 1961, the St. Rita's parish got a visit from the Very Reverend Monsignor Francis M. Beres for a blessing of the site before breaking ground for a new rectory building at Pleasant and Van Buren Streets. This was the site of an old button factory. In the background is the Ossano home and Cass Street School. (Courtesy of the Italian Community Center–Milwaukee.)

There is a small grassy triangle on the northeast corner where Water, Pleasant, and Jefferson Streets converge that offers no clue of what once stood on the site. A three-story Victorian commercial building housed Nick Piano's Triangle Bar from the late 1920s until 1977. According to Nick Piano's son Henry, who was born upstairs, the family bar and restaurant had quite a storied past. Piano's showed Friday night boxing matches before television made it into most homes, making it a lively place. Piano made everyone stand for the national anthem and did not allow off-color jokes. The bar's location made it quite a crossroads, being adjacent to the tanneries and on the border of Greek, Puerto Rican, African American, and German neighborhoods, as well as the Brady Street area Poles and Italians. The elder Piano's tight ship created an environment where all cultures were accepted and got along. As for Henry, this exposure to other worlds just a few stairs down was a great primer for his own path to tolerance, enlightenment, and happiness in life. (Courtesy of the Milwaukee Public Museum.)

Six

PASTIMES, FROM HOMING PIGEONS TO BOCCIE BALL

Recreation and leisure time took many forms for Brady Street neighborhood residents. The Town Club offered live theater and music shows, tennis, and other activities for the gold coast gentry. Saloons served as poor men's social clubs for what little time was left after the long factory hours. Many activities were centered around water, either on the Milwaukee River above the dam or on Lake Michigan. Still other activities were traditions brought here by immigrants, such as the many Polish families who raced homing pigeons and the vacant lots that were filled with lively Italian banter while boccie balls were tossed. Actually that lively banter is itself a sport and still breaks out on random street corners.

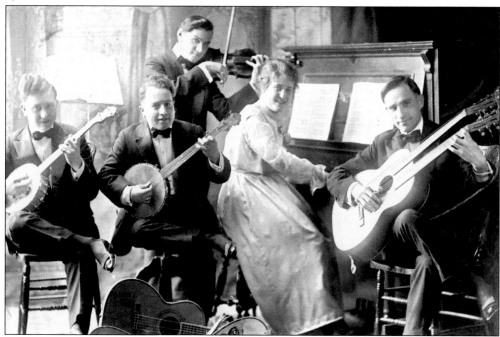

The Vaccaro family band (members unidentified) entertained Milwaukeeans from their east side home base, as this 1916 photograph shows. Thanks to the fight for an eight-hour day and other rights for immigrant laborers, leisure time became a reality for the masses. Before long, countless modes of recreation and entertainment blossomed in the Brady Street neighborhood. (Courtesy of the Italian Community Center–Milwaukee.)

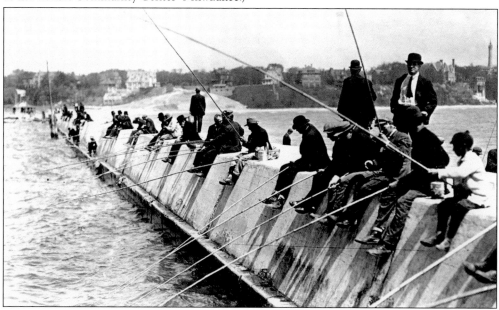

Once the breakwater on Lake Michigan was poured to protect the newly filled shoreline, east-siders and other Milwaukeeans lined up in droves for their daily catch. Poles from the Baltic Sea area as well as southern Italians were experienced fishermen and surely felt right at home on Milwaukee Bay. (Courtesy of the Wisconsin State Historical Society.)

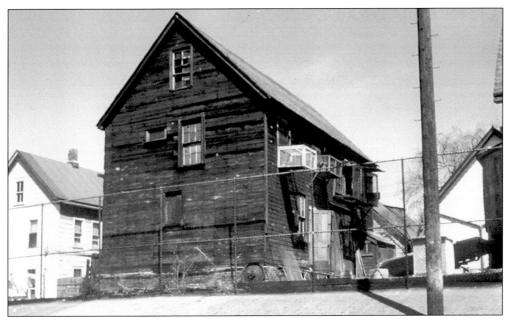

Many garages north of Brady Street served the secondary purpose of a pigeon coop, as the rear of this Kane Place residence shows. Apparently a pastime brought from Poland, residents often met at Wolski's Tavern to race their prized birds for trophies and bragging rights. Flocks were often seen circling the neighborhood. (Courtesy of the Fr. Frank Yaniak collection.)

Italians had their own old country traditions. Boccie, a less-refined version of English lawn bowling, was commonly seen on neighborhood vacant lots. Two such places were the present site of the Arlington Court apartment building and the Park East freeway corridor. The lively banter made this a great spectator sport. Pictured from left to right are Joseph Puccio, Gaetano Gigante, Joseph Carini, and Mariano Crivello. (Courtesy of Betty Puccio.)

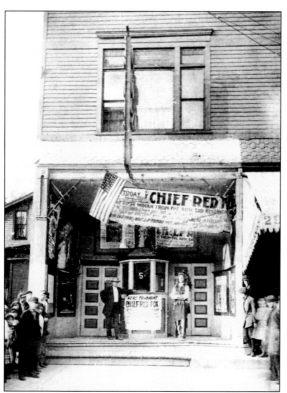

Long before television, the Cozy, a nickelodeon at 1036 East Brady Street, showed moving picture shows. This converted livery stable entertained up to 168 people nightly from 1908 to 1914. This photograph is from that final year. (Courtesy of Larry Weiden.)

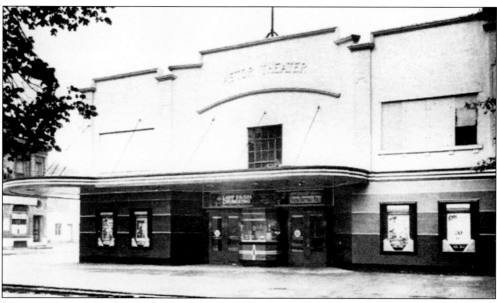

Moving pictures caught on in a big way. In 1915, the 800-seat Astor Theater was built at the southeast corner of Astor and Brady Streets by architect Hugh Miller. The theater hosted vaudeville shows, newsreels, and feature films. An opening day feature article raved that the Astor "even had a ladies room!" It was rescued in 1983 by Jim Searles and now serves as a pharmacy, a diner, and a theater for local arts groups. (Courtesy of the Milwaukee County Historical Society.)

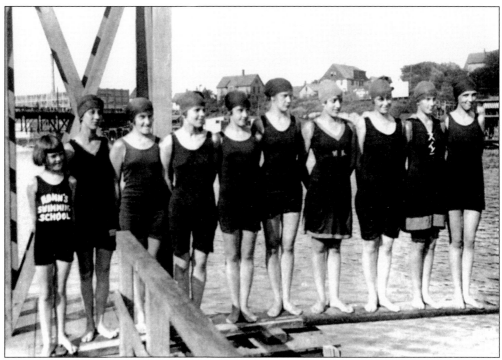

Young ladies in shockingly revealing swimwear pose along a diving board at Rohn's swimming school on the west bank of the Milwaukee River just above the Kilbourn Dam. Rohn's opened in 1856 and trained students to swim while wearing tethered harnesses. Later they could work their way up to diving into the river from various platforms. Notice this diver whose hands seem to be touching St. Hedwig's steeple in the distance. Swimming in the Milwaukee River ceased by the early 1900s. (Courtesy of Milwaukee County Historical Society.)

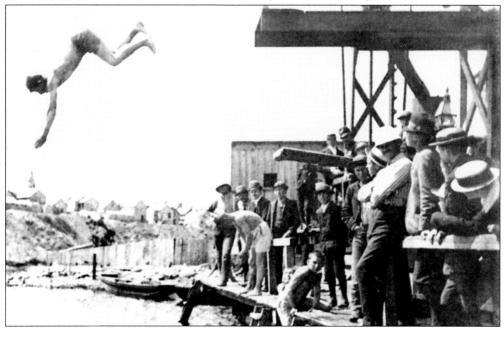

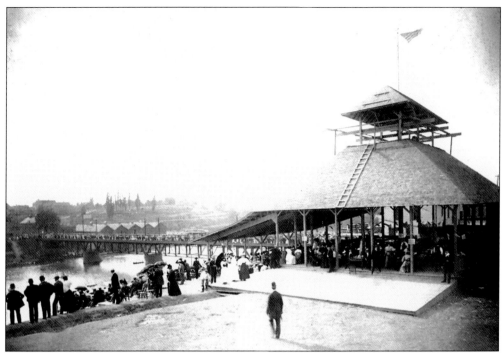

Across the river on the east bank stood Whittaker's and Beckstein's swimming schools, as well as Chute the Chutes, a popular waterslide into the river. Whittaker's also had a sheltered beer garden atop the hill. Notice the North Avenue bridge in the background of the photograph above looking northwest. The photograph below is from Rohn's, looking across the river to the east. These attractions were accessed from the 2100 and 2200 block of North Cambridge Avenue near the present Judge's bar. According to the *Milwaukee Sentinel*, July 5, 1896, saw a record 8,000 people flock to these attractions. (Courtesy of Milwaukee County Historical Society.)

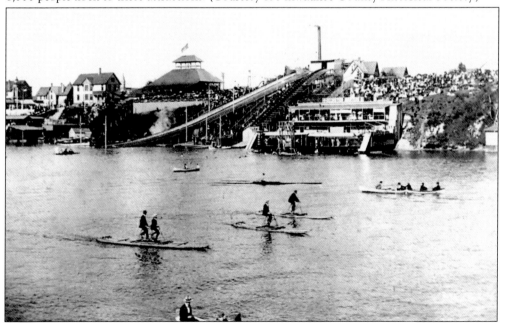

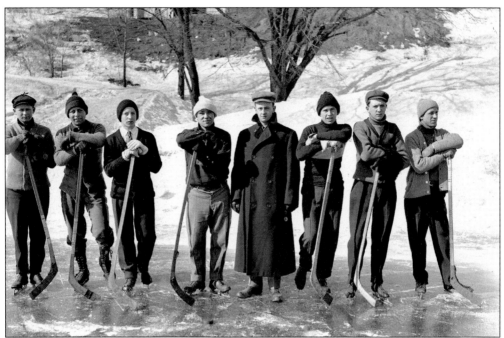

When the Milwaukee River froze, ice-skating became the activity of choice for many east-siders. One could skate from the Brady Street area to the Locust Street bridge and find lots of company along the way. Hundreds of folks would gather for races or mere social gatherings. For young boys, hockey was the activity of choice. Sometimes tussles would break out between rival neighborhoods for the "good ice." Here are photographs of an unidentified hockey team ready for action and then . . . game time! In the background are an ice shed and smoke billowing from Humboldt Yards steam trains. (Courtesy of the Milwaukee Public Museum Sumner W. Matteson collection.)

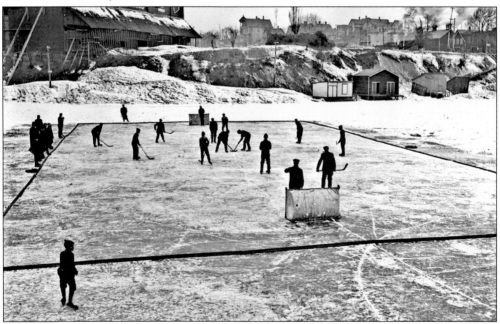

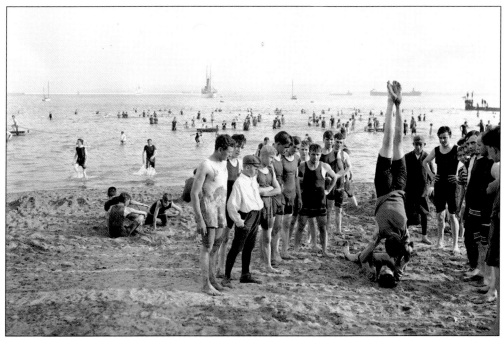

Hot days brought healthy crowds to McKinley Beach a century ago. Here some tumblers show off their skills to onlookers. (Courtesy of the Milwaukee Public Museum Sumner W. Matteson collection.)

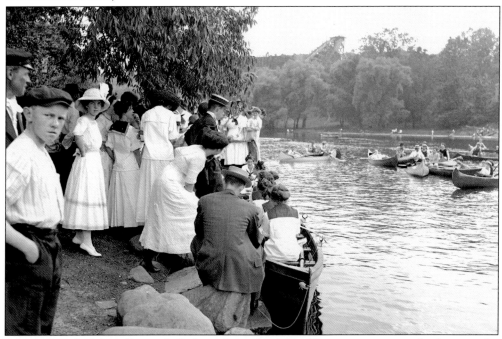

Canoes launched from Riverside Park in the early 1900s. This was a very popular hangout for east-siders through the 1950s. It then suffered from neglect and vandalism until the Urban Ecology Center fostered much-needed attention on the area in recent years. (Courtesy of the Milwaukee Public Museum Sumner W. Matteson collection.)

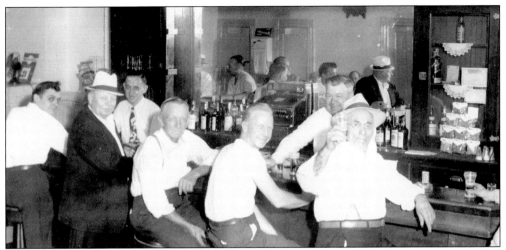

Taverns were the social clubs for the working class. Milwaukee, with its heavy blue-collar population and abundance of competing breweries, seemed to have a tavern on every corner. Taverns offered cheap meals and a ready game of cribbage or sheepshead. Discussions—sometimes heated—ranged from sports to politics. Come to think of it, not a whole lot has changed on this topic. This is Paul Ehlert's tavern when he had the site that is now the Up and Under Pub—certainly no pretense here. The barkeeps are Ray Rewolinski at left and Paul Ehlert himself. (Courtesy of Bob Ehlert.)

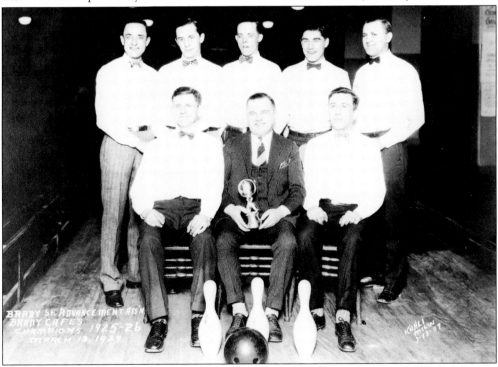

Bowling was another blue-collar pastime. Many bowling alleys were two-lane setups in the basement of taverns. The Pabst tavern, which is now Regano's Roman Coin, was one such venue on Brady Street. This proud trophy-winning team is the Brady Advancement Association of 1925–1926, and the location is the Brady Café. It is not known where the Brady Café was. (Courtesy of Teri Regano.)

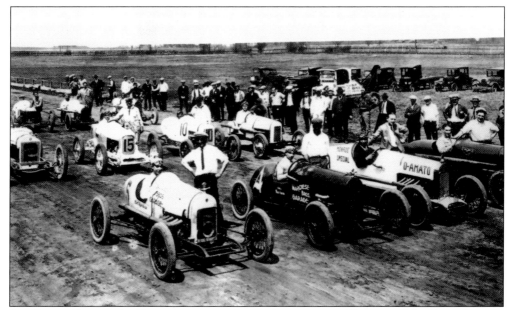

Ray Besasie Sr. owned a Texaco station on the southeast corner of Lyon and Van Buren Streets. Besasie loved to tinker with cars and eventually had his own racing team. The activity around the garage became legendary in the neighborhood. Besasie eventually became the mechanic for a car sponsored by neighborhood grocery store owner Joe D'Amato. Pictured is the D'Amato car in the front row at the Wisconsin State Fair grounds on a converted horse track during automobile racing's infancy. (Courtesy of the Italian Community Center–Milwaukee.)

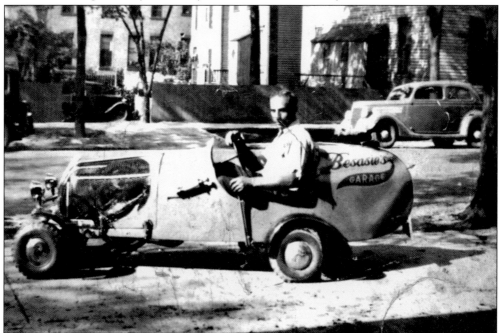

Ray Besasie Jr. poses in front of his home at 1647 North Van Buren Avenue. This car was built by his father out of loose parts and was for tooling around the neighborhood. (Courtesy of the Italian Community Center–Milwaukee.)

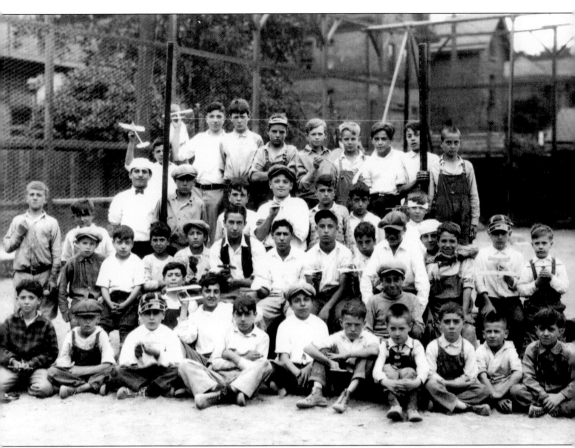

When kids were not lucky enough to have a father who could build them their own race car, they went to Cass Street Playground and joined the Glider's Club. Actually, the Glider's Club was of an earlier era, when the play space was newly created. In 1909, the school board called Cass Street School the second most deficient school for playground space. It was not until 1927 that $7,000 was allocated to raze houses and create a playfield. The houses in this photograph are across the alley on Marshall Street and were also razed a few years later to double the play space. Neighbors initiated a major renovation in 1998. (Courtesy of the Italian Community Center–Milwaukee.)

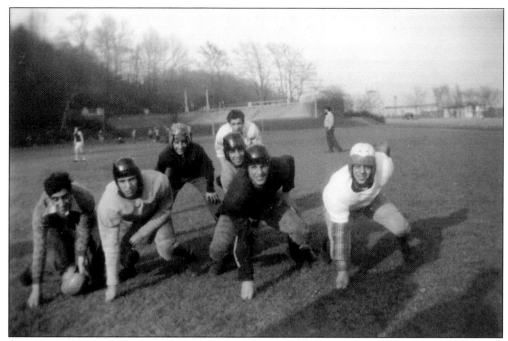

School team sports were another passion for Brady Street area youths. Lincoln High School's 1945 football team sets for a play at a lakefront practice. From left to right are (first row) Joe Vella, Joe Tarantino, John Fazio, and Tony Dentice; (second row) Mike Ray and quarterback Luber Scaffidi. (Courtesy of Augie Ray.)

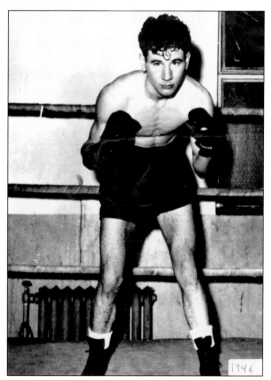

Boxing was a popular diversion for many neighborhood boys. They trained at the Third Street gymnasium on Third and Wells Streets and fought at the Eagles Club and other local rings. Pictured is Sam Cicerello of Lyon Street in 1946. The fighters would box locally for the Golden Gloves and regional winners would move on to the championships in Chicago. (Courtesy of the Italian Community Center–Milwaukee.)

Seven

POSTWAR AND THE FABULOUS 1950s

After World War II, the Brady Street area experienced a period of relative bliss. Jobs were plentiful in the local factories, churches peaked in attendance, businesses thrived, crime was relatively low, and young baby boomers filled local playgrounds with few worries. Thanks to the foresight of the late Fr. Frank Yaniak, a priest at St. Hedwig's Church and an avid photographer, the era has been extensively recorded through hundreds of photographs that he meticulously organized. The neighborhood is lucky to have had Yaniak's foresight, recording everyday people, buildings, and events for the enjoyment of future generations.

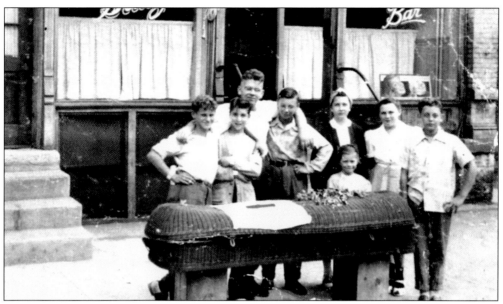

Victory over Japan Day, or V-J Day, August 14, 1945, marked the beginning of a new era of optimism and prosperity. Parties and parades broke out across the western world. A group of Brady Street kids staged a funeral for Japanese emperor Hirohito using an old body basket from the Suminski Funeral Home garage. From left to right are Jerry Kron, Carmen Caputa, Victor Waraxsa, Bob Ehlert, Rosalie Ehlert, tiny Mary Jane Little, Marilee McMullen, and Bob Jazdzewski. (Courtesy of Bob Ehlert.)

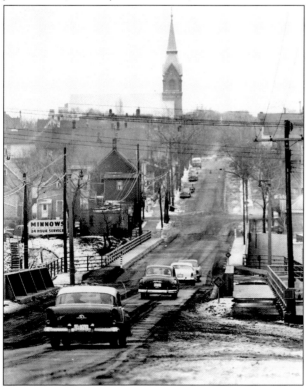

After World War II, all roads seemed to lead to Brady Street and other urban neighborhoods. The economy boomed, compelling factories to hire returning servicemen and servicewomen at rates unseen before. This view south down Humboldt Avenue perhaps symbolizes that move back home. (Courtesy of the City of Milwaukee Department of Buildings and Bridges.)

On January 28, 1947, a blizzard paralyzed Milwaukee. Streetcars, buses, and automobiles met drifts over eight feet tall, making roads impassable. Evelyn Suminski recalled having to walk home through chest-high drifts from Fifty-first Street and North Avenue. Some Brady Street residents exited their homes from second-floor porches. Children of the day, too young to help the dig out, have more romanticized memories. Here Raoul "Rocky" Czerwinski gets a hand from his mother, Frances, in front of their home at 1311 East Kane Place. (Courtesy of Ruth Kelly.)

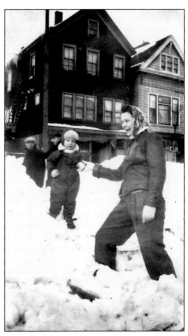

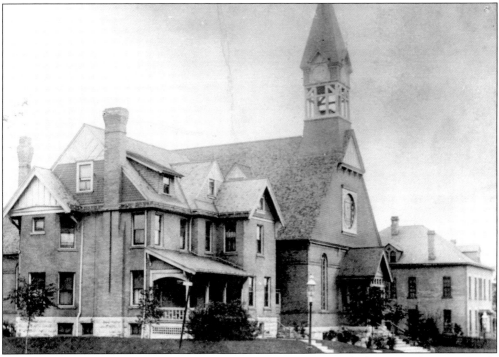

Historically the Brady Street area was overwhelmingly Roman Catholic. St. Hedwig's on Brady Street served the Polish community; St. Rita's served the Italians south and west of Brady Street. An Irish enclave entrenched itself northeast of Brady Street and established Holy Rosary Parish on Oakland Avenue (shown above). Membership and influence of these parishes peaked in the 1950s. Today the three have consolidated into Three Holy Women Catholic Parish, using all three campuses. (Courtesy of Three Holy Women Parish.)

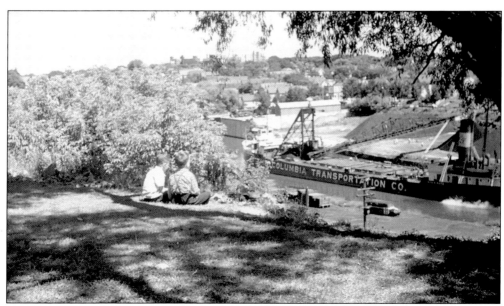

The 1950s were a simpler time. This Norman Rockwell–like image shows two young boys idling blissfully on the hill at Kilbourn Park watching ships unload in the Milwaukee River at the Humboldt Avenue bridge. Ships ceased coming that far upriver in 1958 as a dramatic increase in automobile traffic caused complaints of delays due to bridge openings. The demand for coal also waned with modern home heating methods. (Courtesy of the Fr. Frank Yaniak collection.)

Mugging for the camera before "cruising the avenue," from left to right are (first row) Eddie Ledger and Freddie D'Aquisto; (second row) Joe Piccuro and Frank Sansone. The emergence of the car culture in the 1950s revolutionized teen life. Suddenly, cruising Wisconsin Avenue ogling the opposite sex or showing off one's wheels became the rage. Treks to the Pig 'n Whistle drive-in on Capitol Drive or to the Milky Way drive-in on Port Washington Road were suddenly reachable for Brady Street teens. Incidentally the Milky Way inspired the television show *Happy Days*. (Courtesy of Augie Ray.)

Many spectacular fires occurred in the Brady Street area in the 1940s and 1950s. These incidents—however tragic—are fixed in the memories of residents and are among the neighborhood's most photographed events. This is a two-alarm fire at the Sorolia apartments on Ogden Avenue on June 30, 1946. The incident as seen in the photograph is perhaps most remembered for the tipping over of ladder truck 2. In the background is the Unitarian Universalist church. (Courtesy of Bob Ehlert.)

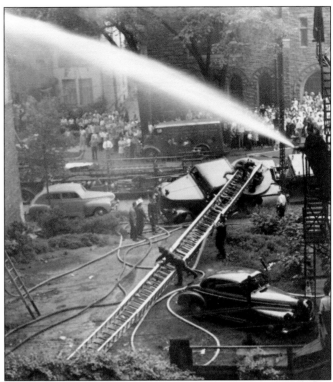

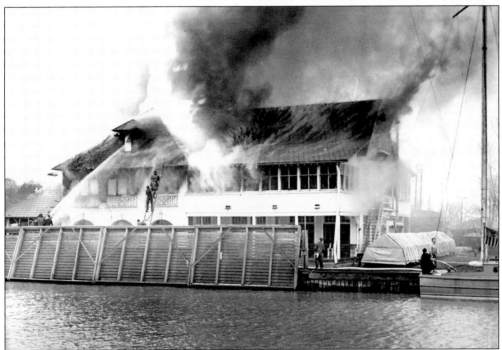

The Milwaukee Yacht club, slated for demolition, went up in flames on November 24, 1943. The barrier in the foreground was erected to prevent debris from the demolition from falling into Lake Michigan. (Courtesy of the Milwaukee Public Library, Humanities Collection.)

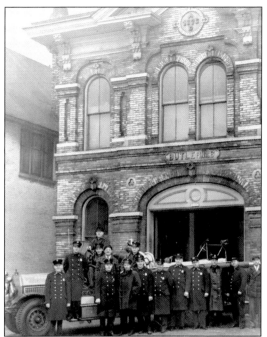

January 7, 1946, was the last day before Engine Company 6 vacated quarters for a remodeling. The neighbors had a ceremonial send-off before the company was to run out of Engine Company 21 on Brewer's Hill. From left to right are (first row) John Cwiklinski, Art Tushaus, Eddie Black, Bronislaus "Brownie" Nowakowski, Jake Zukowski, Lt. Charlie Voelz, Capt. Herman Holtz, ? Strebig, neighbor Mike Stankiewicz, and Pat Hogan; (second row) John Novak, Bill Tiedemann, neighbor Jim Gardner, and Oscar Day; (third row) Sander Van Willigan. (Courtesy of Bob Ehlert.)

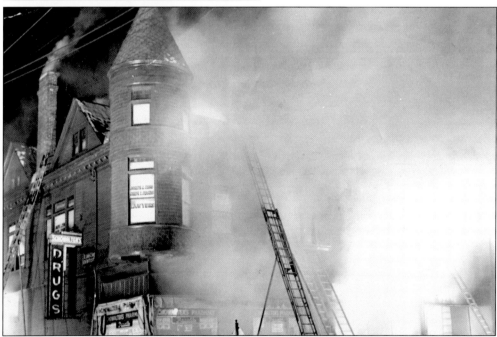

The vacancy of Engine Company 6's quarters for remodeling was foreshadowing for Brady Street's largest fire and arguably the most significant building loss. The Jacob Schowalter pharmacy building was an expansive Queen Anne, Victorian commercial building with residences above. On January 27, 1946, in the early-morning hours, a fire broke out in the basement. A passerby saw smoke and ran to the firehouse to get help only to find it vacant. This delay helped the fire intensify, although the Schowalters and other residents escaped unharmed. (Courtesy of the Milwaukee Fire Department Historical Society.)

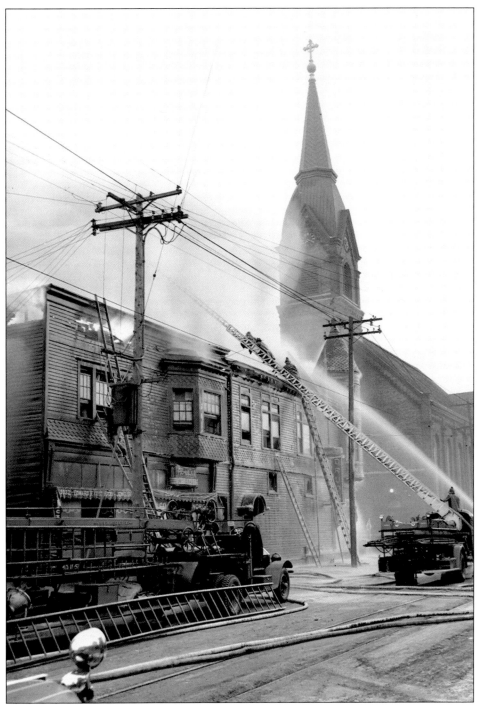

The fire soon spread throughout the 1890 landmark despite the efforts of 125 firefighters and 15 hose lines. This view shows St. Hedwig's Church across the street to the east looming over its neighbor for the last time after 50 years on opposite corners in the heart of Brady Street. Schowalter's was a classic old-time pharmacy with a soda fountain that drew many Brady Street area youths. (Courtesy of the Milwaukee Fire Department Historical Society.)

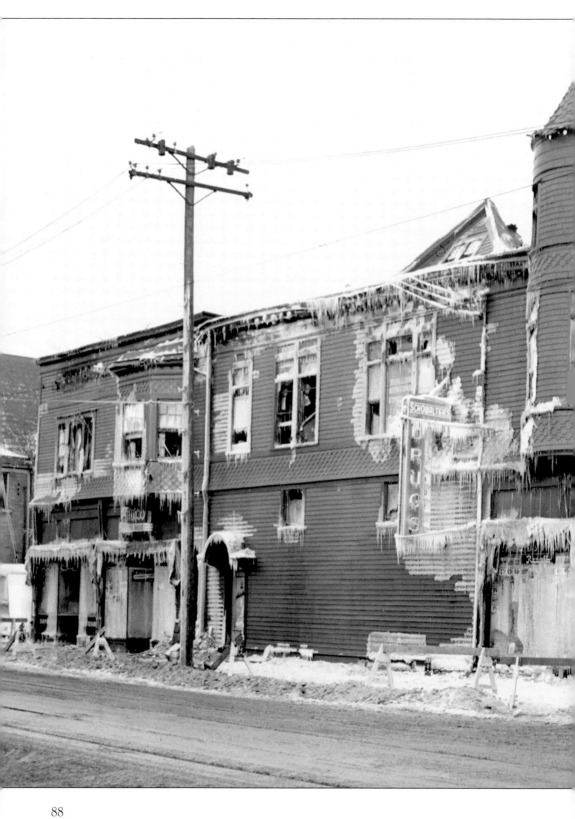

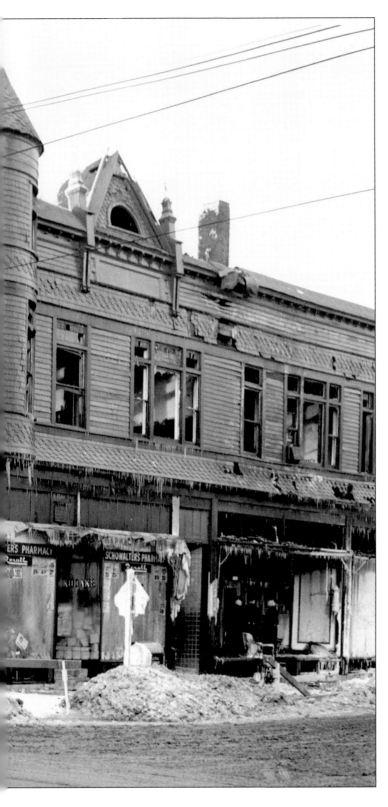

In the aftermath, the blaze destroyed six apartments and seven popular Brady Street businesses. Besides Schowalter's pharmacy, the losses included alderman Alfred Hass's United Radio repair shop, Kosobucki Jewelers, Joe Fumularo's barbershop, the Humboldt Beauty Shop, the budding law office of Joseph Ziino, and John Seng's dental office. Jacob Showalter had a new pharmacy built, a less ornate one-story building on the same site, which now houses the Brady Coin Laundry. (Courtesy of the Milwaukee Fire Department Historical Society.)

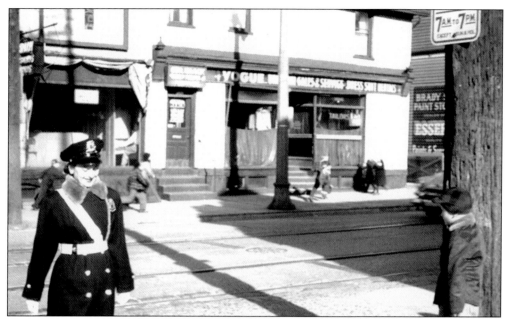

Those who grew up around Brady Street in the 1950s always speak glowingly as they reminisce of a simpler, more innocent time. Here an unidentified child waits for a crossing guard's assistance on the way to St. Hedwig's School in 1952. (Courtesy of the Fr. Frank Yaniak collection.)

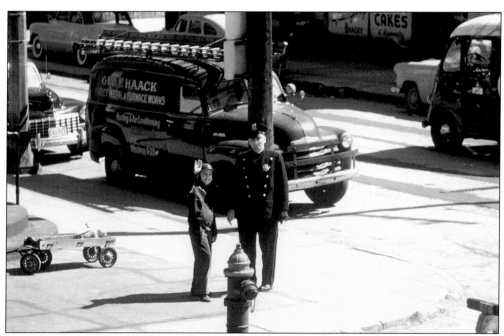

Brady Street beat officer Sam Bay poses with young Dave Siefert. Bay turned 100 years old in August 2007. Notice the George Haack furnace repair truck. Haack served neighborhood customers from the Sikorski building on the northeast corner of Franklin Place and Brady Street. (Courtesy of the Fr. Frank Yaniak collection.)

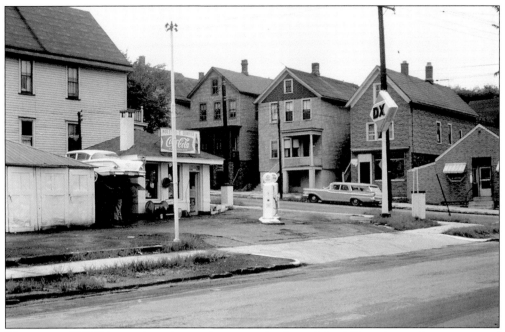

This quaint DX filling and service station sat at the foot of the hill at the southeast corner of Humboldt Avenue and Kane Place for many years. Notice the outdoor hydraulic repair lift. This site is now a condominium complex and an Italian restaurant. (Courtesy of the Fr. Frank Yaniak collection.)

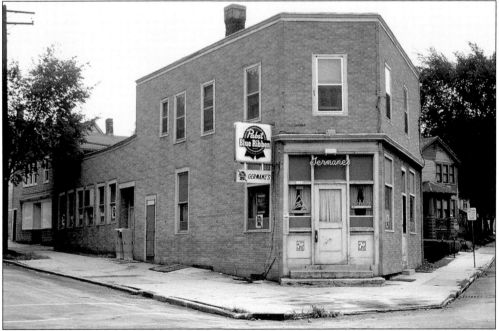

One block east of the gas station, at the triangle formed by Pulaski Street and Kane Place, stood a tavern called Germane's, as this 1957 photograph shows. This is now a vacant lot. (Courtesy of the Fr. Frank Yaniak collection.)

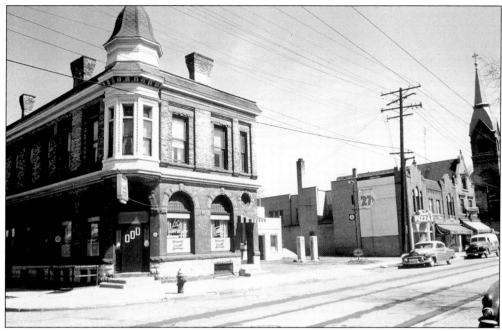

The 1957 lineup on the north side of Brady Street between Astor Street and Humboldt Avenue is the Happy Go Lucky Tavern, Eddie's gas station (just 27¢ a gallon), Trio's Pizza, Glorioso's, the United Radio repair shop, and St. Hedwig's steeple in the background. (Courtesy of the Fr. Frank Yaniak collection.)

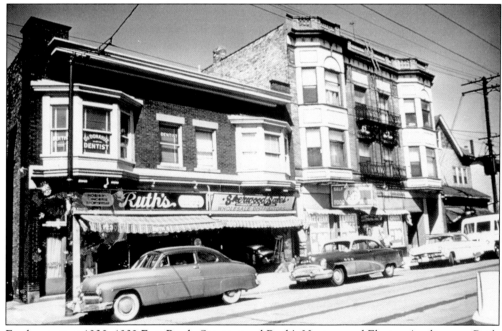

Farther east at 1230–1232 East Brady Street stood Ruth's Hosiery and Electra Appliances. Both storefronts are now combined into Oriental Coast Restaurant. At 1234 East Brady, the A&P grocery store was huge compared to the many corner mom-and-pop shops in the neighborhood but tiny relative to today's standards. (Courtesy of the Fr. Frank Yaniak collection.)

Both of these buildings were razed for a parking lot a few years after this photograph was taken. At left, this unusual residential building appears to have seen several additions through the years. La Rosa's bar and diner holds the Pabst sign. Many upper flats on Brady Street have oriel bay windows to allow a bit more space and natural light. Notice the elm tree, a common sight on Brady Street before Dutch elm disease inflicted the region. Trees are now making a comeback along the street. (Courtesy of the Fr. Frank Yaniak collection.)

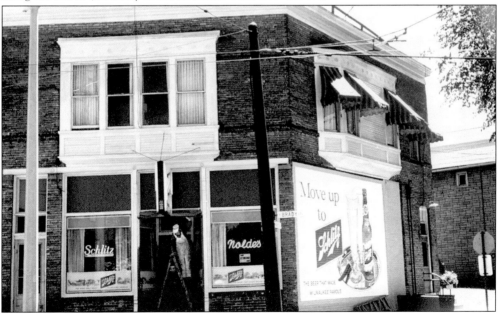

Nolde's bar stood on Warren Avenue and Brady Street in the 1950s. Owner Mike Eitel has helped transform the neighborhood with several bars and restaurants in sensitively and creatively restored buildings. This building, Eitel's first effort, is now called the Nomad World Pub and draws an eclectic crowd, especially to its sidewalk seating on summer evenings. (Courtesy of the Fr. Frank Yaniak collection.)

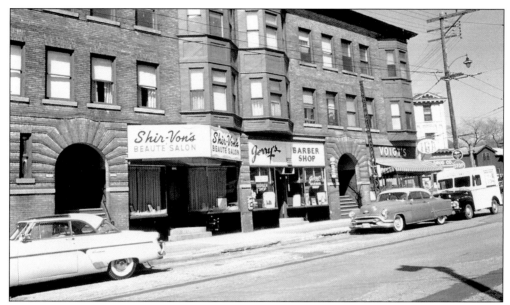

The Hiles building had a colorful history before it was leveled for a strip mall parking lot in the early 1980s. Built by George Hiles in 1895, the cream-brick building housed many businesses through the years and had apartments priced to accommodate families. Clothes lines were strung out back, and the rear served as a sandlot baseball field for young boys. It later served the counterculture movement on Brady Street, and by the 1980s, it fell into blight and was the site of several fires. (Courtesy of the Fr. Frank Yaniak collection.)

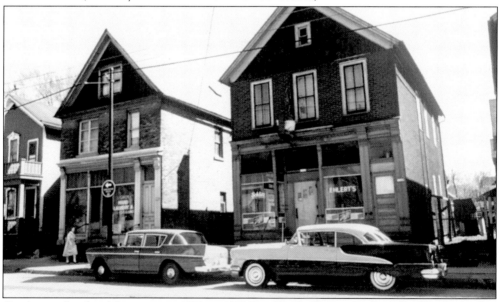

On the south side of the street in 1959, at 1317 East Brady Street, was the Moy Hand Laundry. Next door to the right at 1311 was the final of several Brady Street locations for Ehlert's Tavern. These buildings are typical of many on the street for their large plate glass shop windows, the indented main shop door, and a second door with access to the shopkeeper's flat above. These buildings now house Rochambo Coffee Shop and Jo Cat's Pub, respectively. (Courtesy of the Fr. Frank Yaniak collection.)

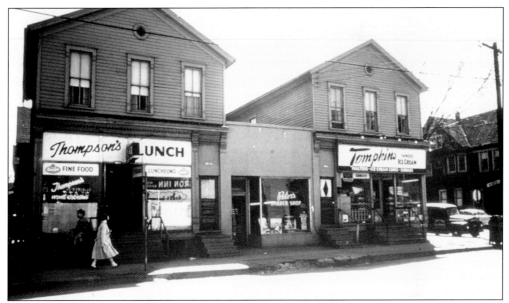

Farther west was a pair of simple commercial buildings built as income properties by pharmacist Rudolph Weise in 1882. A tiny and very plain infill building was added years later. In this 1953 photograph, from left to right are the Thompson's Lunch counter, Peter La Barbara's barbershop, and Tompkin's Ice Cream Parlor. Since the early 1990s, Mimma's restaurant, a popular Italian eatery owned by Joe and Mimma Megna, has gradually taken over all three buildings. (Courtesy of the Fr. Frank Yaniak collection.)

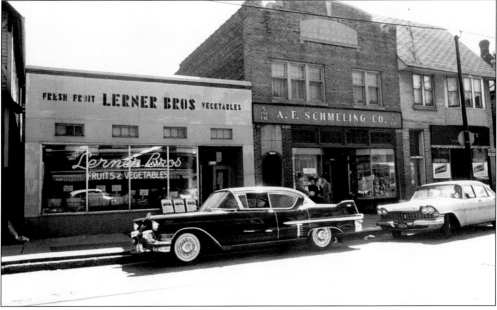

Lerner Brother's produce was a fixture at 1233 East Brady Street. Built in 1935 for Jacob Lerner, this is the only building erected on Brady Street during the Great Depression. That explains its rather austere design despite being built by prominent Milwaukee architect Herman Buemming. It is now the popular Bella's Fat Cat restaurant and custard shop. At right is the Schmeling five-and-dime. (Courtesy of the Fr. Frank Yaniak collection.)

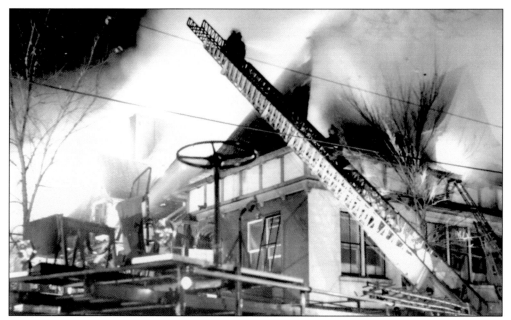

Yet another spectacular blaze hits the Brady Street area. On the night of November 5, 1953, carelessly discarded smoking materials caused a four-alarm fire that completely destroyed the Town Club on Farwell Avenue just south of Brady Street (now the site of the CVS parking lot). The Town Club recovered but rebuilt in Fox Point, following Prospect Avenue gold coast residents up the north shore. (Courtesy of the Town Club.)

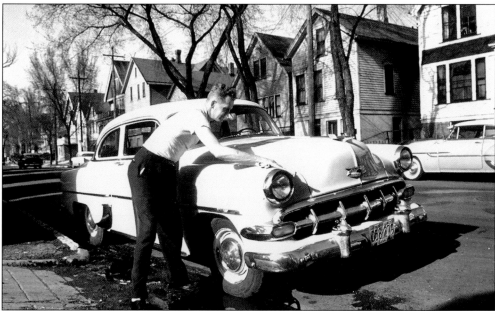

Warren Avenue resident Roy Baker shows that Brady Street area residents had "made it" by the 1950s as he shines up his 1953 Chevrolet. Residents of Warren Avenue were not likely to be able to afford a car nor have the time to tidy it up a generation or two before this. Ironically the American love for cars helped create unforeseen changes to Brady Street and other urban neighborhoods in the ensuing decades. (Courtesy of the Fr. Frank Yaniak collection.)

Eight

ABRAHAM LINCOLN DID NOT SLEEP HERE

No, there was no known sighting of Abraham Lincoln nor were there any recorded sightings of that more notorious guy from Illinois who seemed to hang out in every resort in Wisconsin, Al Capone. However, dozens of noteworthy and famous folks called the Brady Street area home or were schooled in the neighborhood. Remarkably the claims to fame are as diverse as the makeup of the neighborhood. Famous authors, politicians, athletes, inventors, musicians, entertainers, and even war heroes dwelled in neighborhood homes, shopped in Brady Street shops, and ambled down local streets. This chapter features some of the street's famous former neighbors. Also recognized are the longest-running business owners on Brady Street who have become local celebrities in their own right.

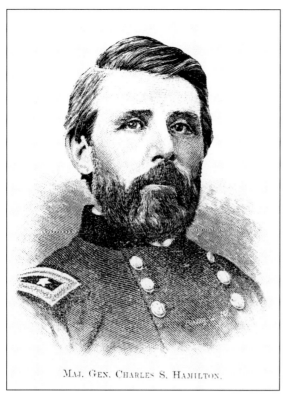

MAJ. GEN. CHARLES S. HAMILTON.

Charles S. Hamilton was born in New York in 1822 and later attended West Point Academy. He was promoted to general during the Civil War. During a battle in Mississippi, Hamilton performed heroically despite having his horse shot from under him and his sword hilt shattered by a bullet. He retired to Milwaukee, where he ran a linseed oil business. During a Civil War reunion in 1889, his regiment marched to his home at 1510 North Marshall Street, shown below, to honor its now sickly old commander. (Courtesy the Menefee family.)

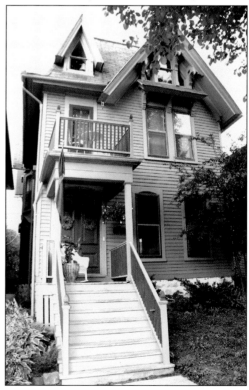

Another war hero lived in Brady Street's midst. Franklin Van Valkenburgh grew up at what is now 1420 North Humboldt Avenue and went to Cass Street School in the 1890s. Van Valkenburgh joined the navy and earned his way up to captain assigned to the USS *Arizona*. The *Arizona* took the biggest hit at Pearl Harbor, losing over 900 of its crew. Van Valkenburgh was gravely injured but continued to direct operations, which saved many of his crew, earning him the Medal of Honor. He is entombed in his ship under the USS Arizona Memorial at Pearl Harbor. (Courtesy of the U.S. Naval Historical Center.)

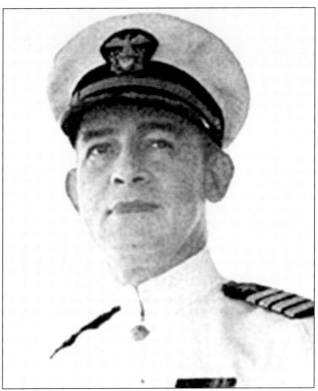

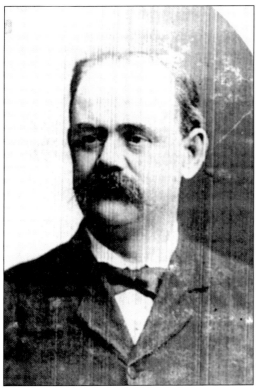

One name that arises often in the history of Brady Street's Polish community is Francis Niezorawski. A police officer, local alderman, and public works commissioner, he became a builder and was the mason contractor for St. Hedwig's Church. The rebellious Niezorawski was an instigator in two Brady Street riots. The largest broke out between old line and progressive factions at the church. Niezorawski, who lived at 1722 North Franklin Place, died in a tragic fall down a chimney at a construction site. (Courtesy of Carl Ferguson.)

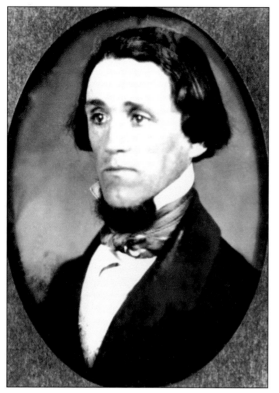

Christopher Latham Sholes never gained riches and did not gain fame until he had long passed. But he may have impacted the world more than any other neighborhood resident. Sholes invented the typewriter, which helped gain employment for uncounted scores of women in the secretarial field in the late 1800s. Besides his inventing hobby, Sholes worked as editor of the *Milwaukee Sentinel* and dabbled in politics. The Sholes family lived for a time at what is now 1679 North Humboldt Avenue (pictured), which is unfortunately now a vacant lot. (Courtesy of the Milwaukee County Historical Society.)

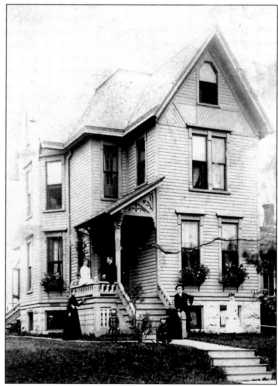

George W. Peck wrote a newspaper column that eventually became a series of books known as The Bad Boy Adventures. These humor stories were harsh and politically incorrect by today's standards but a century ago earned him national fame. He parlayed his fame into a political career and became the mayor of Milwaukee in 1890 and governor of Wisconsin a year later. Peck lived in a row house that he had built at 1620 North Farwell Avenue. (Courtesy of the Milwaukee Legislative Reference Bureau.)

Many Brady Street area buildings were designed by previously mentioned prominent local architects. One noteworthy architect, Herman Buemming, built his family home in the neighborhood. Buemming designed the classical revival dwelling at 1012 East Pleasant Street for his new bride, Gertrude, in 1901. The style was popular at the time because it was prominently used at the Chicago world's fair a few years earlier. The beautifully restored home is on the National Register of Historic Places. (Author's collection.)

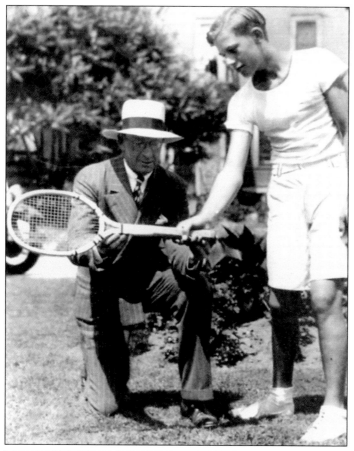

At the exclusive Town Club, the only role for a Polish immigrant kid was to shag tennis balls. That changed when coach Mercer Beasley took scrawny Frankie Paikowski (of Sobieski Street, now Arlington Place) under his wing. Under the name Frank Parker, he won many tournaments, including Wimbledon in 1949, and earned a place in the National Tennis Hall of Fame. The picture at left shows Parker getting instructions from Beasley. The second picture is a postcard image of the Town Club, which stood south of Brady on Farwell Avenue. (Courtesy of the Town Club.)

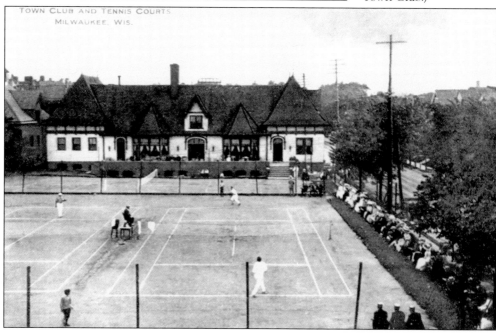

TOWN CLUB AND TENNIS COURTS
MILWAUKEE, WIS.

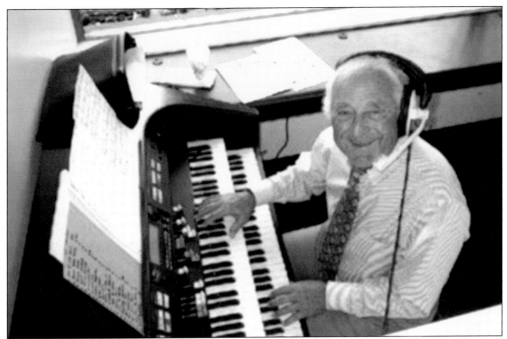

Frank Palleria went to Lincoln High School when it was predominately Italian in the 1940s. As a standout music student, he went on to a long career as organist Frank Charles, playing organ accompaniment to energize and entertain fans at Milwaukee Bucks and Milwaukee Brewers games. This photograph was taken at a Milwaukee Brewer game on August 20, 2002. (Courtesy of Frank Palleria.)

Here is another standout Lincoln High School music student. Al Jarreau, shown as a young freshman, graduated in 1958 and went on to distinguish himself as the only vocalist in history to win Grammy Awards in three different categories, jazz, pop, and rhythm and blues. Among his dozens of hits is "We're in This Love Together." Jarreau still keeps in touch with his old friends from the Brady Street neighborhood. (Courtesy of Augie Ray.)

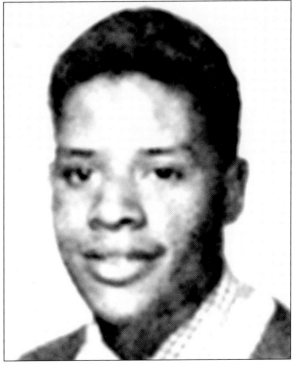

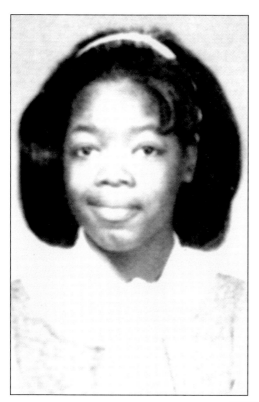

Oprah Winfrey is one of the most recognizable people in the world—and perhaps one of the richest and most influential. Winfrey, who lived on North Ninth Street, went for a few years to Lincoln Junior and Senior High School, as this 1967 yearbook picture shows. She ultimately graduated from Nicolet High School in Glendale. "Oprah was intelligent and very involved in school activities," said one friend and classmate, "She was also mischievous, and enjoyed good natured teasing." (Courtesy of Leo Harper.)

Freddie Brown is another face from the 1967 Lincoln Junior and High School yearbook worth a mention. "Downtown" Freddie Brown and Clarence Sherrod, who remains in Milwaukee as an attorney, were the best high school basketball guard combination Wisconsin has ever seen. Lincoln had a long run as a state championship team. Brown went on to become the leading scorer in the Seattle Supersonics' history and was captain of their NBA championship team in 1979. (Courtesy of Leo Harper.)

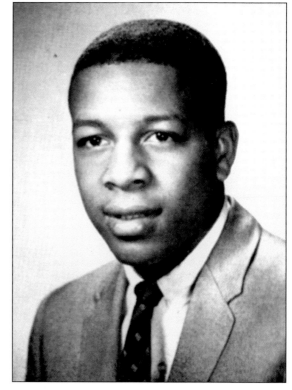

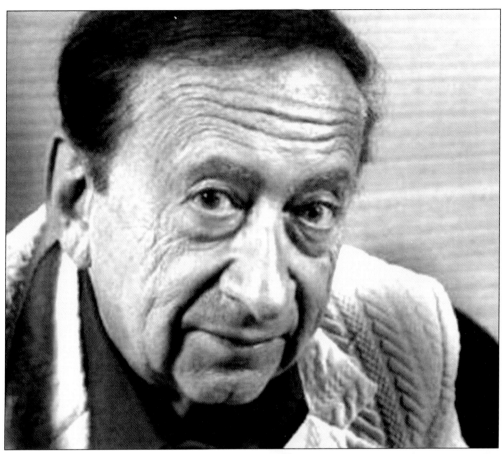

Robert Bloch was born in Chicago but
came to Milwaukee at the request of Brady
Street resident Harold Gauer to speech
write for aspiring mayor Carl Zeidler. Bloch
was a prolific writer of fantasy, horror, and
science fiction and wrote over 200 stories
and 22 novels. He is best known for the book
Psycho, a thriller he wrote in 1959 while
living in an apartment above Glorioso's store.
Alfred Hitchcock made a movie of the same
name based on Bloch's book. (Courtesy of the
Robert Bloch Fan Club.)

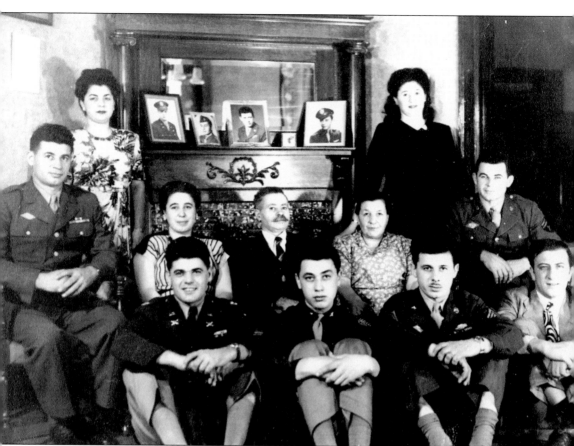

The Cuda family lived for a time at 1640 North Cass Street and later just across the Holton Street Viaduct. The Cudas' claim to fame was having seven members serve in World War II at one time—all of whom returned safely. From left to right in this 1945 photograph are (first row) Anthony, Frank, James, and Roy Maro (husband of Jane Cuda); (second row) Pat, Elizabeth, Frank Sr., Rosa, and Dominic; (third row) Jane Cuda Maro and Mary Cuda Sicchio. Along with the five in uniform, Jane Cuda Maro served in the army, and Mary Cuda Sicchio served with the Red Cross. (Courtesy of Elizabeth Zierer.)

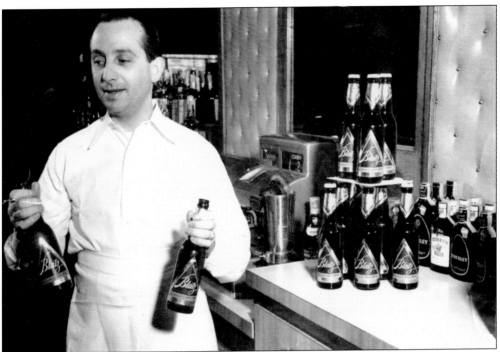

Mom-and-pop shops and other small businesses have the odds stacked against them. The Brady Street neighborhood has seen hundreds come and go through the years. The following pages recognize some with staying power—the anchors of the Brady Street neighborhood so to speak. Joe Regano, shown here in his first bartending job, opened Regano's Roman Coin in 1966. Regano's has not missed a beat under Joe's daughter Teri's watch since Joe passed away a few years ago. (Courtesy of Teri Regano.)

Pitch's restaurant, on the northwest corner of Humboldt Avenue and Hamilton Street, is known for its barbecued ribs as well as Italian food. Peter Picciurro opened Pitch's in 1942. This photograph was taken in 1957, before several expansions. (Courtesy of the Fr. Frank Yaniak collection.)

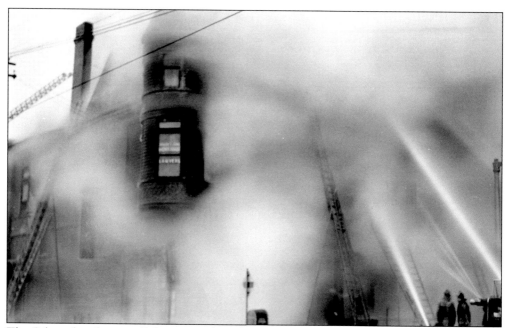

The Schowalter fire is well documented in chapter 6, but there is more to the story. The one window not impinged by fire or smoke in this picture is, perhaps symbolically, the four-month-old law office of Joseph Ziino. His office was lost, but his business survived and moved to the east end of Brady Street. It has since expanded and is called Ziino, Germanotta, Knoll, and Christiansen. Ziino, now retired, still has a damaged typewriter and water-stained law books salvaged from the ruins some 61 years ago. (Courtesy of the Milwaukee Fire Department Historical Society.)

It is difficult to walk by the corner of Humboldt Avenue and Brady Street without being hypnotized by the odor of fresh rolls and Italian cookies. This has been happening to neighborhood residents since 1950 when Peter Sciortino began his bakery on the southwest corner. Sciortino himself retired a decade ago, but loyal employees known as the Vella family, including Gluseppi (pictured), his siblings Maria and Luigi, and their parents Salvatore and Maria, have continued the tradition under the Sciortino name. (Author's collection.)

Four generations of Wolskis have run this tavern since 1907—the longest continuous run for a family in Milwaukee under one license. Bernard Wolski moved the building from Brady Street to Pulaski Street after a fire damaged the second floor. (Courtesy of the Fr. Frank Yaniak collection.)

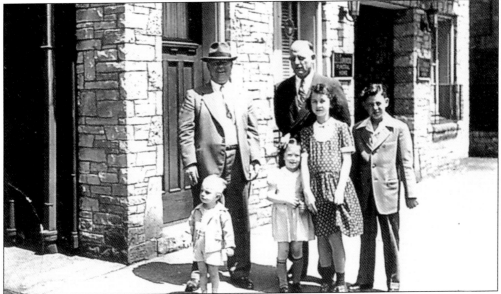

The Suminski family funeral home has had the longest run on Brady Street. John I. Suminski started in 1905 as an undertaker in a time when the deceased was laid out in the home. Pictured in the early years are, from left to right, (first row) Ed Suminski Jr., Mary Jane Ehlert, Rosemary Ehlert, and Bob Jazdzewski; (second row) John I. Suminski and Frank Jazdzewski. The family has always been active in neighborhood affairs, and Pat Suminski, granddaughter of John I., remains one of the stalwarts of neighborhood involvement. (Courtesy of Don Jazdzewski.)

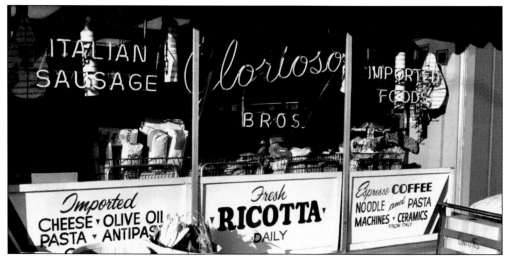

One of the most important and recognized businesses on Brady Street is Glorioso's. Felice Glorioso sold fish from a basket in his tiny hillside town in Sicily, earning enough liras for passage to America. His legacy of pedaling food has carried on to three of his sons, Giuseppi (Joe), Ignatius (Eddie), and Salvatore (Teddy), as well as Joe's son Felice (Felix). Glorioso's began in 1946, and the family has been active and supportive of neighborhood concerns since. Besides the imported Italian foods and grocery items, Teddy runs a jewelry store upstairs. The family won the Wisconsin Small Family Business of the Year Award in 2007. Pictured below in 1965 are, from left to right, (first row) sister Rosalie and parents Felice and Theresa; (second row) Joe, Eddie, Nick, Ted, Anthony, and Chuck. (Above, courtesy of Gail Fitch and the Jim Eukey collection; below, courtesy of the Glorioso family.)

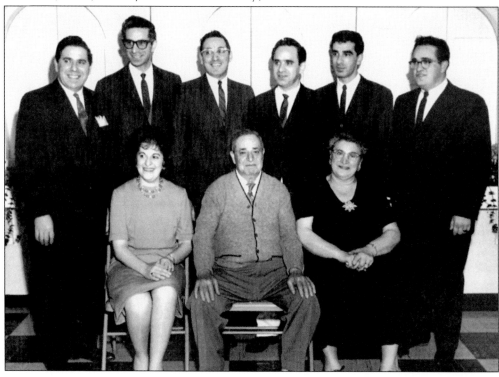

Nine

"POWER TO THE PEOPLE, RIGHT ON" BRADY STREET

The American dream in the late 1950s and early 1960s was redefined for second- and third-generation Americans, and Brady Street was no exception. Freeways were built, and the edge of town was transformed from farm fields to subdivisions of ranch homes. Second- and third-generation Brady Street residents joined the exodus to larger homes on lots farther from the city center. In their wake, Brady Street, like most urban neighborhoods, waned in its allure. Buildings fell into disrepair, and mom-and-pop shops succumbed to the growth of chain stores and shopping malls. Brady Street, however, found a new niche. Beatniks from the Layton School of Art on Prospect Avenue began congregating around Brady Street. This hint of an arty counterculture, coupled with cheap rents, eventually paved the way for hippies, students, artists, and radicals. Businesses catering to this new demographic soon flourished. Brady Street went psychedelic and has never been quite the same.

Many of the more traditional ethic shops began to close in the 1960s as a steady migration to the outskirts of town and suburbs took hold. Ranch homes on larger lots sizes, in a safer environment to raise a family, became the next step for the second and third generations of the Brady Street–area immigrants. Back on Brady, young members of the counterculture began opening eclectic shops of their own. Here are Bill Odbert's leather shop at 1316 East Brady Street and Arlyn Fishkin's Silver Shop at 1208 East Brady Street. The Silver Shop is now Brewed Awakenings. (Above, courtesy of Bert Stitt; left, courtesy of the Fr. Frank Yaniak collection.)

Another popular store for the counterculture was 1812 Overture record shop. This is now the location of the Dogg Haus restaurant. This tiny storefront has been an incubator for many budding businesses through the years. The record shop later expanded into the Ross building, which is now the Brady True Value Hardware store. (Courtesy of the Fr. Frank Yaniak collection.)

Joynt Venture, a head shop selling smoking paraphernalia at Astor and Brady Streets, was popular with the counterculture but a point of contention with more traditional neighbors. (Courtesy of the Fr. Frank Yaniak collection.)

The counterculture developed its own newspapers, the *Bugle American* and *Kaleidoscope*. Both had Brady Street roots and created enough of a stir that no-nonsense Milwaukee chief of police Harold Brier had squads assigned to monitor their activities and allegedly intimidate writers and staff. (Courtesy of Mark Goff.)

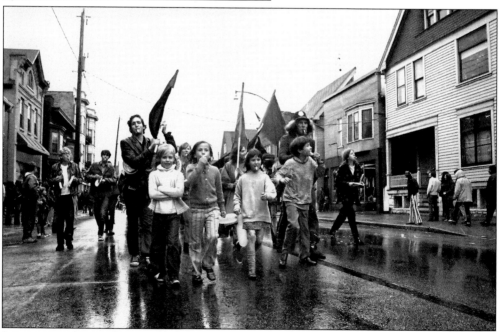

Protests, marches, and apparently kazoo bands could break out at any minute on Brady Street as this 1970 photograph shows. (Courtesy of Mark Goff.)

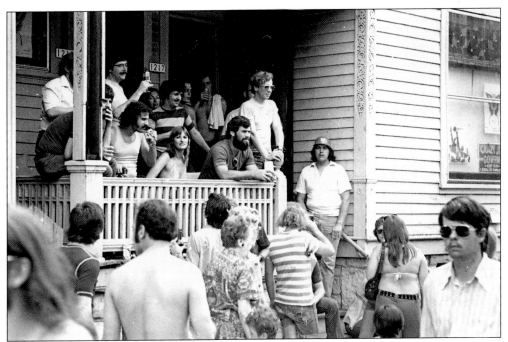

Folks just hanging out on porches and on stoops in front of businesses have long been a Brady Street tradition. The counterculture kept that going. Rent was as little as $80 in some cottages, which allowed underemployed young adults the time to hang out and party. A food cooperative opened on Kane Place in 1968 that also helped those who idled away the day to be fed for pennies. (Courtesy of Bert Stitt.)

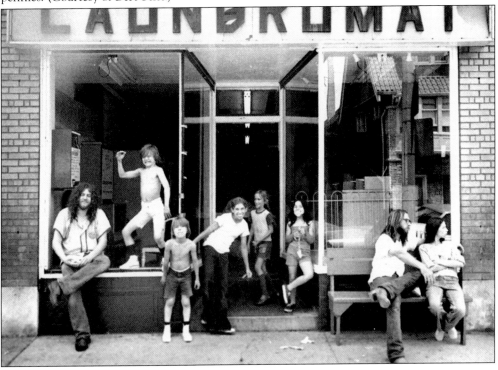

Street artists, musicians, and other performers became the norm in the neighborhood. In the background, notice the Volkswagen microbus, which was a common vehicle for hippies as they hit the road. (Courtesy of Mark Goff.)

Starting in September 1970, Brady Street merchants and active residents held a twice annual festival that drew people from all over the Midwest. It rivaled the early years of Summerfest in popularity. Brady Street kids take advantage of the barricaded street to show off their wheels during the early hours before the masses arrive. (Courtesy of the Fr. Frank Yaniak collection.)

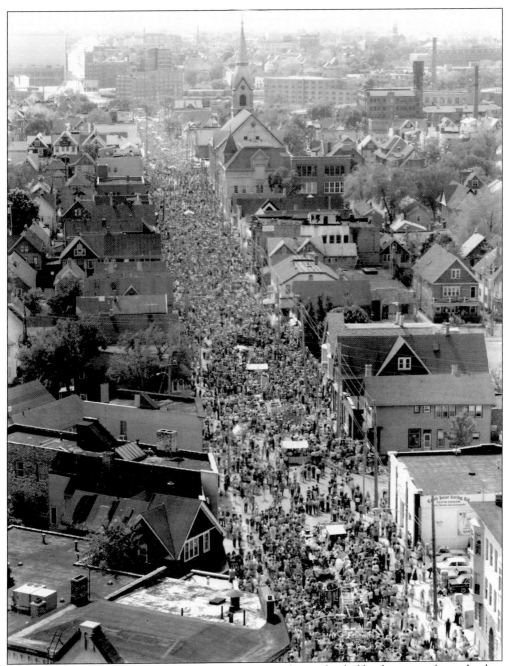

This photograph from Prospect Tower apartments shows the half-mile mass of people that converged on Brady Street for the spring festival in 1975. By 1980, the event had worn out its welcome and began to draw rowdy crowds that were less respectful of the neighborhood. (Courtesy of Bert Stitt.)

Brady Street festivals featured food from local restaurants, crafts and other handmade goods, and live music. The festivals were not restricted to the counterculture as these images show. People of every stripe have always felt more welcome on Brady Street than many other settings. (Courtesy of Mark Goff.)

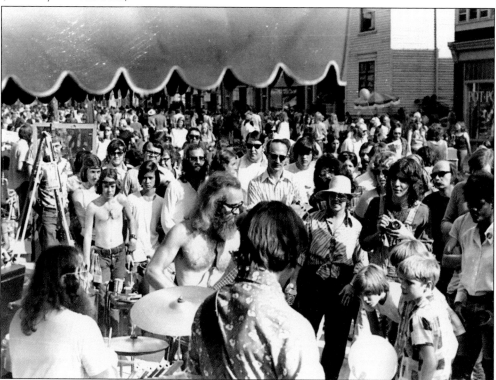

Ten

LOOMING BLIGHT AND A GRASSROOTS RESURGENCE

By the 1980s, the hippie movement had burned out. Vacant stores became commonplace, and many homes deteriorated further. High-rise buildings built for elderly residents were compelled by law to accept drug- and alcohol-dependant persons without treatment for their afflictions. Liquor stores soon proliferated, and panhandling and street crime increased. The vacant Trostel Tannery was slated as the ideal site for a state prison. Brady Street had hit a low point.

In the mid-1980s, residents and shop owners united to fight for their survival. In the ensuing decade, a streetscape and beautification project commenced, and many structures were renovated. Many old buildings are finding new uses. Condominiums are growing seemingly overnight. Upscale clothing shops and boutiques are thriving, and outdoor cafés and coffee shops add energy to the street. Urban living is hip again, and Brady Street is in the midst of an unparalleled renaissance. Perhaps what is most remarkable is the neighborhood's rich diversity, for Brady Street retains pieces of over a century of growth and change.

In the late 1960s, freeway building caused the demolition of thousands of homes and businesses, cutting through the heart of many neighborhoods. Opposition led to the abandonment of the route south of Brady Street between Lyon Street and Ogden Avenue, but the buildings were already lost. Here is Halle's pharmacy building, which was on the northwest corner of Franklin Place and Ogden Avenue. (Courtesy of the Milwaukee County Historical Society.)

This 1920s-era apartment building and several others of a similar vintage were among the losses for the freeway to be built along Ogden Avenue. This leg of the freeway, called the Park East, was to loop from Ogden Avenue down the lakefront south to the Hoan Bridge. (Courtesy of the Milwaukee County Historical Society.)

As the hippie movement waned, Brady Street fell onto harder times. While some of the standbys from other eras remained successful, many commercial and residential buildings fell into disrepair and neglect by the 1980s and 1990s. Some were being lost to demolition. The 1875 Charles Sikorski building was one of many board-ups seen on the street in that era that was at risk. (Courtesy of the Fr. Frank Yaniak collection.)

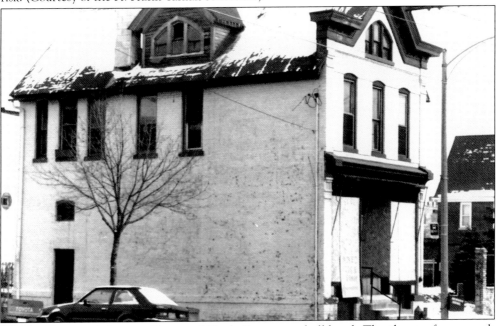

This building at Arlington Place and Brady Street was bulldozed. The threat of more such losses, as well as a rise in crime and aggressive panhandling on the street, prompted action and residents and business owners to organize. In 1988, the New Brady Street Area Association was formed by a grassroots group dedicated to improving life in the Brady Street neighborhood. (Author's collection.)

In the early 1990s, Barry Mandel saw potential in the long abandoned Park East freeway corridor. It was potential that apparently no one else saw, for he had to go to Japan to entice investors for his condominium project. No American bank would support investment in the Brady Street area at that time. What a difference a decade makes. By the year 2000, condominiums and apartments, high- and low-rise, were popping up like weeds. This is part of the Mandel Group's East Point Commons. (Author's collection.)

In 1997, Julilly Kohler, who had been active in the neighborhood for several years, invested nearly $2 million in the old Huebsch Laundry site and created a complex of shops and living space. The project, called the Passeggio, took one of the street's most blighted properties and transformed it into a hub of investment and activity that has helped legitimize Brady Street for other investors. (Author's collection.)

Joe and Mimma Megna, who once owned Tina's, a small corner grocery in the neighborhood, opened Mimma's restaurant in one-third of this three-storefront building in 1989. It has been successful enough to expand three times. Besides quality Italian food, Mimma's sports one of the more appealing facades on the street. (Author's collection.)

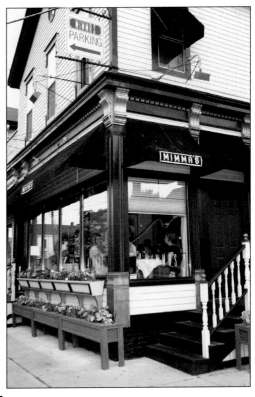

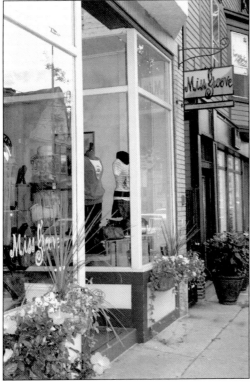

Miss Groove is one of the many fashion boutiques to come on the Brady Street scene in the last decade. This building was once the Cornell Market as seen on page 20. (Author's collection.)

Among the many upscale shops to open doors on the street include Waterford Wine Company at 1327 East Brady Street and Cocoa Bella at 1323 East Brady Street. The numerous sidewalk cafés give Brady Street an almost Pairsian atmosphere in the summer. (Author's collection.)

The Brady Street festival of the counterculture days has long passed, and of late, a variety of smaller themed festivals and events have been held. In 2006, a wine- and cheese-tasting festival took over the street. It included rides such as this Ferris wheel in front of Regano's Roman Coin. (Courtesy of Teri Regano.)

While some of the area has gone upscale, Brady Street remains a draw for artists, students, punk rockers, grungers, and countercultural types of the modern era. Head shops have been replaced with tattoo parlors and body-piercing studios. Brady Street never seems to shed itself of any group, new ones just keep adding to the mix. (Author's collection.)

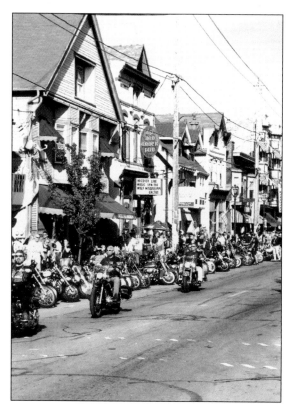

Harley Davidson's 100th anniversary occurred in 2003, and bikers from around the world swarmed on Milwaukee like bees. Brady Street was often cited as a highlight for visiting bikers. Burnout contests were among the showstoppers. (Courtesy of Dan Gilipsky.)

The gold coast along Prospect Avenue has completely transformed, but it is not any less golden. Most of the mansions have succumbed to the high demand for luxury living in high-rise apartments and condominiums. Most of what remains of the original mansions serve institutional uses like the Charles Allis Art Museum and the Wisconsin Conservatory of Music. (Courtesy of Jim Henderson.)

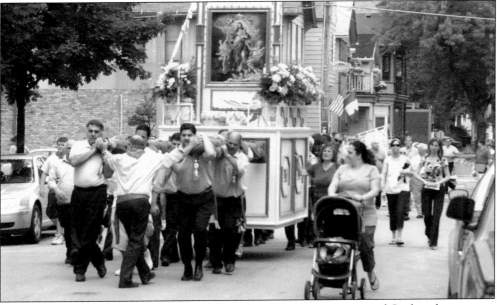

An annual processional of religious societies honoring patron saints of Sicilian hometowns marches annually through the Brady Street neighborhood. In this photograph, members of the Madonna Del Lume, paying homage to the patron saint of Porticello, Sicily, parade down Astor Street carrying its icon. Such cultural and ethnic traditions continue to make life in the Brady Street area uniquely vibrant and exciting. (Author's collection.)

DISCOVER THOUSANDS OF LOCAL HISTORY BOOKS
FEATURING MILLIONS OF VINTAGE IMAGES

Arcadia Publishing, the leading local history publisher in the United States, is committed to making history accessible and meaningful through publishing books that celebrate and preserve the heritage of America's people and places.

Find more books like this at
www.arcadiapublishing.com

Search for your hometown history, your old stomping grounds, and even your favorite sports team.

Consistent with our mission to preserve history on a local level, this book was printed in South Carolina on American-made paper and manufactured entirely in the United States. Products carrying the accredited Forest Stewardship Council (FSC) label are printed on 100 percent FSC-certified paper.

MADE IN THE USA